THE MASSEY LECTURES SERIES

The Massey Lectures are co-sponsored by CBC Radio, House of Anansi Press, and Massey College in the University of Toronto. The series was created in honour of the Right Honourable Vincent Massey, former Governor General of Canada, and was inaugurated in 1961 to provide a forum on radio where major contemporary thinkers could address important issues of our time.

This book comprises the 2021 Massey Lectures, "Out of the Sun: On Race and Storytelling," broadcast in November 2021 as part of CBC Radio's *Ideas* series. The producer of the series was Philip Coulter; the executive producer was Greg Kelly.

ESI EDUGYAN

A graduate of Johns Hopkins University and the University of Victoria, Esi Edugyan was born and raised in Calgary, Alberta. She is the internationally bestselling author of *Washington Black*, which was a finalist for the Man Booker Prize, the Los Angeles Times Book Prize, the Carnegie Medal for Literary Excellence, and the Rogers Writers' Trust Fiction Prize, and won the Scotiabank Giller Prize. It was chosen by both the *New York Times* and Barack Obama as one of the best books of 2018. Edugyan's other novels include *Half-Blood Blues*, a finalist for the Man Booker Prize, the Women's Prize for Fiction, and the Governor General's Literary Award, and the winner of the Scotiabank Giller Prize and the Anisfield-Wolf Book Award; and *The Second Life of Samuel Tyne*. She is also the author of *Dreaming of Elsewhere: Observations on Home*, which is part of the Kreisel Memorial Lecture Series. She has held fellowships in the U.S., Scotland, Iceland, Germany, Hungary, Finland, Spain, and Belgium. She lives in Victoria, British Columbia.

OUT OF THE SUN

On Race and Storytelling

ESI EDUGYAN

ANANSI

Published in Canada in 2021 and the USA in 2021 by House of Anansi Press Inc.
www.houseofanansi.com

25 24 23 22 21 1 2 3 4 5

Library and Archives Canada Cataloguing in Publication

Title: Out of the sun : on race and storytelling / Esi Edugyan.
Names: Edugyan, Esi, author.
Series: CBC Massey lectures.
Description: Series statement: The CBC Massey lectures
Identifiers: Canadiana (print) 20210222077 | Canadiana (ebook) 20210222093 |
ISBN 9781487010508 (hardcover) | ISBN 9781487009885 (EPUB)
Subjects: LCSH: Art and race. | LCSH: African diaspora in art. | LCSH: Race awareness in art. | LCSH: Minorities in art. | LCSH: Arts—History. | LCSH: Arts and society. | LCSH: African diaspora—History. | LCGFT: Essays.
Classification: LCC NX650.R34 E38 2021 | DDC 704.03/96—dc23

Cover design: Alysia Shewchuk
Text design: Ingrid Paulson
Typesetting: Laura Brady

House of Anansi Press respectfully acknowledges that the land on which we operate is the Traditional Territory of many Nations, including the Anishinabeg, the Wendat, and the Haudenosaunee. It is also the Treaty Lands of the Mississaugas of the Credit.

With the participation of the Government of Canada
Avec la participation du gouvernement du Canada

We acknowledge for their financial support of our publishing program the Canada Council for the Arts, the Ontario Arts Council, and the Government of Canada.

Printed and bound in Canada

MIX
Paper from
responsible sources
FSC® C103567

For Kofi and Abena

CONTENTS

OUT OF THE SUN

OUT OF THE SUN

INTRODUCTION

IN *THE ART OF WAR*, SUN TZU explains how an army should use the sun to its advantage. "Camp in high places, facing the sun," he advises. Mountains are preferable to valleys, illuminated places to dark ones. When confronted with a hill or a bank, an army should "occupy the sunny side."

He was interested, in part, in exploiting human weakness. Flooded by light, the eye struggles to see clearly. Edges are shadowed, and it becomes difficult to know what, if anything, is there. A vast force appears smaller, shrunken by our muddled perceptions. The people on the margins remain unseen. At the last moment, they come pouring out of the sun like phantoms breaking through into the world of men.

I have always liked this image, of the hidden rushing suddenly into view. The idea of who is seen, and who remains unseen, has been at issue in so many recent conversations about race, gender, sexuality. A world

of shadows edges our written histories, and to attempt to see it is not just to recover one human story, but to piece together the larger picture hidden from us. These lectures look directly at those figures and stories lost to us, and at what it means for us collectively to have been unable to see them.

We speak so much about the "universality" of being human, about the similar things that connect us. I don't want to lose sight of that. But in some ways, such talk camouflages the problem of difference — not difference itself, but our diminishment of it. It can be just as illuminating, I think, to look at the opposite. This year of lockdowns and sickness has starkly revealed the gulfs between our lives. Experiences divide us, uneven access to necessities and comforts, different childhoods, traumas, faiths. If we wish to understand each other, we must first acknowledge the vastly unequal places from which we each speak, the ways some have been denied voices when others are so easily heard.

In some respects, history functions the way language does. Our words have agreed-upon meanings; this is how we understand each other. Language is a shared tool based on a shared idea of reality, and its points of reference must generally be the same for it to work. But language can be changed by revoking one's consent — by refusing, for example, to agree on the meaning of a word, or by disavowing it, or by changing its evocations entirely, until it becomes something else, something new. History also works on the principle of an established reality. And

just as language can be changed, for better or for worse, by revoking one's consent, so can our collective stories. What happens when our once-settled narratives become unsettled? What happens when they begin to shift the boundaries of what we have long believed?

These pieces were begun as the first COVID-19 lockdowns were put into place and finished just as efforts are underway to vaccinate against the virus. What got me through this year, with its street protests and its anguish, its illness and joys and bewilderment, was the quiet dredging up of these lives from other times, and the attempt to discover how, if at all, they have shaped our own.

Part memoir, part travelogue, part history, these pieces are meditations on identity and belonging, and on the consoling refuge that stories can be. I am not a historian, only a storyteller with an interest in overlooked narratives, and I've always been curious as to why we sideline some stories and mythologize others. What social and political instincts inform our remembering; how much are our omissions the result of apathy, of indifference? I wanted to know the living, breathing people who have remained beyond our sight, occupying the shadows.

CHAPTER ONE

EUROPE AND THE ART OF SEEING

1

IN THE SPRING OF 2018, I had the unusual experience of sitting for my oil portrait. This does not, I think, mean what it used to. The invention of photography has made it easier to be a painter's subject; it is now possible to avoid the long hours once required of sitters. It has freed them from needing to assume the same pose over and over, allowed them faster escape if the painter is bad-tempered or boring, shallow or arrogant. Such mercies work both ways: I am sure the stories of annoying sitters are legion. It is a fascinating relationship, in any case, because it suggests an intense intimacy and the abrupt severance of it. The painter will finish the painting; the sitter will leave and not return; the two might never speak again. That interlude together, however brief, represents not

just a physical moment in time, but the filtering of an identity through incremental judgements that may or may not render the final image truthful.

The painter John Hartman was a warm and soft-spoken man with an unassuming voice. When he arrived at my home, on the coast of Vancouver Island, his calm eyes swept over the sun-filled room as he quickly identified the Barker Fairley portrait above my dining room table. Of course, I thought, of course he would make a swift artistic diagnosis of my family's modest collection. He set to work right away, having me take up different poses throughout the open rooms, his conversation pleasant and economical, his gaze sharp and assessing, but somehow politely so. His project was a series of oil portraits of Canadian writers within settings meaningful to them, and he had spent the morning flying a drone over my house and its surroundings, over the partitioned waters of the lagoon and the ocean, across the rocky vistas of the old fortress of Fort Rodd Hill, with its red-roofed lighthouse, over the grey mass of Hatley Castle and the migratory-bird sanctuary, its riot of fighting swans and geese. I have lived in this place for over ten years, yet seeing the pictures taken by his drone, I'm surprised — how pure and convenient it all looks, how free of the anxieties and judgements I sometimes lay upon it. This recalibration of perception will also be applied to my face. This has no doubt always been the case with painters' subjects; who you are is not who others see.

But in the moment, sitting for Hartman, I did not think of this. In the moment I thought about how I needed to shop for red-leaf lettuce and toothpaste, how I needed to call my family in Calgary. I thought about Lucian Freud, the European portraitist renowned for the vicious way he painted skin, with all its moles and rashes and folds of fat. I thought about the months he'd spend in-studio with a single subject, cooking roasted quail dinners for them in his kitchenette, acting out skits and singing at the top of his lungs, inviting the sitter to sing along. I thought about Hartman's quiet way, and how grateful I was, as I didn't much feel like singing. My mind skipped like light across water, stopping only to listen to Hartman's occasional comments or respond to his cues. And so it seems that, inherent in every sitting, however thrilling, is absence. You absent yourself; the painter withdraws into his thoughts. These absences may or may not come to inform the piece. What is clear for the sitter, though, is that being painted confers status. Not necessarily social status — though throughout the history of portraiture, the insistence on rank through representation has essentially been the point — but, rather, the reverence of being the object of prolonged attention.

For all this attention, however, what is also clear for the sitter is the quiet dismantling taking place. Agreeing to be painted — or, as in some historical cases, being forced into it — is in no small way a surrendering of your identity. We fool ourselves into believing we have some measure of control over how we are perceived. Under

the painter's gaze, we dissolve into a kind of boundless-
ness. All of our attempts to assert our identity, through
clothes, objects, expressions, get shattered. We are taken
out of ourselves, become open to every outward interpre-
tation — first by the painter, then by the viewer — until
we become another being entirely.

REPRESENTATIONS OF PEOPLE of African descent in
Western art have been contentious, to say the least. Not
that there are many to see. In my twenties, I was granted
several arts residencies in Europe, and I would spend my
hours wandering the galleries and museums of its cities,
too poor and too distracted to eat. And though I found
much to admire, I felt uneasy walking the halls of eight-
eenth- and nineteenth-century portraiture. If pressed
for time, I would always choose contemporary art over
older portraiture. It didn't occur to me to ask myself
why. But in room after room of European portraits, I
saw souvenirs from a world wholly removed from me.
I could delight in the skill, be awed by the balance of
light and shadow, admire the cherry-cheeked children in
their impossibly white gowns, even feel anguish at the
sadness of certain scenes. But some other dimension was
missing. Was it simply that I could see no continuance,
no recognizable iteration of my own forebears?

Perhaps my ambivalence also came from certain
threads I sensed missing. For these exhibitions repre-
sented renditions of the same Western story, a story

of wealth and expansion. Black people *are* present, but as footmen, slaves, lady's maids, magi. The African as magus is a saint and bringer of gifts; the African as savage inhabits a darkness so all-devouring only the light of Christianity can penetrate it. These images bear out across the long centuries of portraiture, and they amount to a verdict of sorts. If one of the unavoidable eventualities of art is to act as social history, what story is being handed down to us? Black bodies are less living, breathing people than repositories for cultural anxieties. Blacks are an expression of status, of Christianity's reach, of white morality. They are rarely, until the twentieth century, just human beings, living human lives.

2

MANY YEARS AGO, I FOUND myself in the overstuffed halls of Scone Palace in Scotland. I'd been living some hours away, in a castle perched above the great fields of Midlothian, a guest at a writers' residency. I wanted to see more of the country before I had to leave it. The castle I'd been living at had an air both calm and frantic. The days were lazy, open, shaped only by a sprawling evening meal shared among the residents. During the afternoons, to avoid disturbing others, no one was allowed to speak. I would walk the grounds with a fellow Canadian, a lovely writer from an island on our east coast who, as a connoisseur of human absurdity, told outrageous stories as we crossed fields as pristine and uninhabited as some

imagine the outer planets to be. I adored it there, but it was frustrating, too — the silence was broken by the phone ringing at every hour, the castle's Dame calling to check up on the residency's steward, a kind, thin, hassled man with an explosion of tawny curls who ran about in a state of panic and apology, seemingly terrified that at any moment she might, like a figure of nightmare, leap from a closed cupboard. There were the little skirmishes between the writers, the little jealousies and romances. It is churlish, I know, and spoiled to complain about staying in a castle. But it was with some relief — and some sadness as well — that I set out north.

Scone Palace was another world. One approached it in much the same way one creeps towards a mirage, with a sense it is possibly fraudulent. Built in the Georgian Gothic style, it was a dark, hulking mass high above the River Tay. At the heart of its gardens lay an exquisite maze; I have always had a terror of and an attraction to mazes, drawn by their complications but knowing that to enter them with my sense of direction is to risk having the search party called out. The interiors of the palace were as lavish as its exterior walls were stark, the rooms filled with lush velvet chairs, blue-and-gold silk rugs, draperies and mantels and chandeliers that spoke of aristocratic Georgian excess. Passing through the Gothic library into the Ambassador's Room, I was surprised by a portrait of two very elegant young women. It was for many reasons unusual, not the least because one of the sitters was a Black woman.

The piece, painted in 1778, was until the 1990s referred to as simply a portrait of Lady Elizabeth Murray. The presence of her darker companion, though central, was completely overlooked. Variously attributed to the German neoclassical painter Johan Zoffany and the British artist Joshua Reynolds, the painting is now believed to be the work of Scottish artist David Martin, based on the style, the clothing, and the sitters' gestures. In the portrait, which has an air of arresting strangeness to it, Lady Elizabeth is dressed in a muted pink-and-white gown, her porcelain skin rouged, her expression full of warmth and mischief, her pale hand holding a book as a sign of her intellect. To her left, as if captured mid-stride, is Dido Elizabeth Belle, the young woman of colour. She was in fact Lady Elizabeth's cousin, the two motherless girls raised together. She too looks mischievous and happy, but her movement marks her as physically irrepressible against Elizabeth's restraint. Her station is further indicated by the platter of fruit she is carrying for her mistress, and by the soft grip of Lady Elizabeth's outstretched hand on her wrist — a gesture of affection, yes, but also seemingly one of possession. On her head Dido wears a white turban with a feather, a stand-in for the "Oriental," the exotic.

The renowned scholar Edward Said described the Orient as "the place of Europe's greatest and richest and oldest colonies, the source of its civilizations and languages, its cultural contestant, and one of its deepest and most recurring images of the Other." For much of

the eighteenth and nineteenth centuries, the idea of the Orient was set in opposition to European ideals of rationality, civilization, and modernity. Because "the Orient" was partly located in French North Africa, a transference occurred: any African or person of African descent could be linked to notions of Orientalism. From this transference emerged the figure of the Moor. The Moor was not at first an actual Black person, but a watery, elusive, generalized North African figure without a fixed racial identity. By the nineteenth century, however, he became more deeply grounded in his Blackness, though still carrying faint strains of the Far East.

SLAVERY HAD LONG BEEN a feature of European expansionism, from the barbarian invasions of the Roman Empire to enslavement in the eastern Mediterranean and Russia. Most of these slaves were white. This changed with the shift towards Africa in the mid-fifteenth century. More than twelve million people left sub-Saharan Africa, some passing through the Middle East and North Africa before being shipped to the colonies. The Atlantic trade continued for nearly four hundred years, changing the character of every place it touched. This included the physical makeup of many nations' populations. From the fifteenth century onward, the Black presence became more pronounced throughout Europe, particularly in port cities. As a result of this increased visibility, Blacks began to appear more

frequently in art, their representation usually in some way linked to their condition as slaves. This is not to say that the people depicted are always images of living, breathing figures; they only rarely derive from actual sitters. Rather, they are visual manifestations of an idea of Blackness, an idea informed by slavery.

The European relationship to slavery was very different from its American counterpart. In England, for example, where riches poured in from the colonies to build great cities and underwrite upper-class lives, few Englishmen had any real contact with slavery beyond the knowledge of its existence as something going on "over there." Very few Englishmen settled in the colonies; instead planters employed proxies, "overseers," to run things — often the working poor from Great Britain and the Isles — while they themselves lived distant, comfortable lives across the waters.

And so portraiture of Blacks was tied to an imagined idea of Black people, and of all that Blackness could suggest. The African became a stand-in for the expression of a multitude of conflicting beliefs and ideas. A Black face could be used to symbolize the darkness of the non-Christian world, or conversely, to signify the spread of Christianity throughout the continents. It could be one thing, or its opposite, or both at the same time, the conflicting meanings left to coexist.

It is slaves living in grand houses rather than those living on plantations who are most present in portraiture from the sixteenth to the late eighteenth century.

They appear in "grand-manner" paintings, in which the wealthy are pictured in idealized settings meant to emphasize and capture that status for all eternity. To have a portrait painted was, whatever other impulses informed it, an expression of power. And in these portraits, Black servants are often shown staring adoringly up at their masters, their heads wound in colourful turbans and wearing robes whose brightness makes an obvious contrast against the more sober and elegant clothes of their betters. In the European academic tradition, whose principles were widespread by the seventeenth century, colour was believed to appeal to the senses and was measured against the monochromatism of drawing, which was thought to appeal to the intellect. This dichotomy between wildness and reason was seen to govern the races, too, according to Enlightenment-era theories. And so passionate colours were tied to passionate people, while a lack of colour expressed civility and intelligence.

In his extravagant dress, a Black pageboy became the literal embodiment of his master's riches, his servitude sometimes made clear by a silver ring in his ear or a silver collar around his neck. Black musicians and court performers also served to express this wealth. They are fantasias of slave life, implying a satisfaction with one's lowly role and the implicit superiority of the master or mistress, whose dignified bearing cannot help but inspire deference. The images glorified a world so far divorced from the penury of plantation labour, from

the brutalities of the transatlantic voyage, that the gulf is astonishing.

THERE ALSO LIVED IN EUROPE many people of African descent who were not slaves. Many children from mixed-race relationships been taken to England, and this is the group to which Dido Elizabeth Belle belonged. Dido was the illegitimate daughter of Maria Belle, probably an African slave captured from a Spanish ship in the West Indies by Rear Admiral Sir John Lindsay, Dido Belle's father. Lindsay was the nephew of the most powerful judge in the country, Lord Mansfield. After the death of her mother when she was six years old, Dido's father took her to England to be raised in Lord Mansfield's home in a manner befitting their rank. Lady Elizabeth, the cousin foregrounded in the painting of the two women, had also been sent to live at Kenwood House after the loss of her own mother. I imagine the two girls would have shared a blindsided devastation mixed with shocking good luck, a feeling of being decoupled from a life that had barely begun. And yet, though some details remain obscure, it's said that the positions they occupied in the household were very different. Lady Elizabeth — pale-skinned, light-eyed — was in all respects treated as the vulnerable family member she was. Dido's lot was murkier. She was not quite sister, not quite servant, asked only sometimes to dine with guests; only when the plates were scraped and the coffees drained was she invited to sit with the

ladies and take a turn about the gardens with them. In one account by an American expatriate in London, he described the surprise of seeing Dido walking arm in arm with her cousin. He seemed uneasy with the genuine fatherly affection with which Lord Mansfield treated "the Black," and he was not the only one.

Some felt that Lord Mansfield had allowed his paternal feelings for Dido to cloud his judgement. In 1772, he made a landmark ruling in the case of *Somerset v. Stewart*. Charles Stewart, a British customs agent, had taken his newly purchased slave James Somerset to England, where Somerset briefly escaped, only to be recaptured. Stewart then intended to sell and ship Somerset to Jamaica. But Lord Mansfield decreed that a master could not take a slave out of Britain by force as slavery was unsupported by English common law. This ruling was viewed as a key piece of legislation in the eventual abolishment of the slave trade. A recent biographer of Lord Mansfield has suggested that the great judge was less anti-slavery crusader than someone who disliked slavery but was reluctant to annoy slave owners or to appear to threaten their financial interests, and that he hoped things could carry on as they'd been. And yet Mansfield made the ruling in full awareness of the shockwaves it would send through English society. We will never know how much his love for Dido played into this decision that would reshape the modern world.

· · ·

AS I STOOD IN THE AMBASSADOR ROOM of Scone Palace
with its smell of antiseptic and dust, gazing at the portrait
of Dido and Elizabeth, I was struck by the peculiar artifi-
ciality of its symbols, as if what was being expressed was
the opposite of what we are meant to see. The exuberance
of Dido's striding body; the awkward raising of her fore-
finger to her cheek; even her calm, relaxed smile: all of
this was meant to suggest a certain playfulness, a certain
ease and joy. But to me, these signs of well-being are like
wallpapering over old plaster; they disguise nothing. If
anything, they only bring into sharper relief the terribly
fractured realm Dido was forced to occupy. How soul-
crushing it must have been to live in a kind of in-between
world, neither a servant nor fully of the family's blood,
valued and devalued, an object of both paternal love and
social disgust. When asked recently if seeing this paint-
ing had changed my feelings about eighteenth-century
portraiture, if it had lessened my sense of exclusion, I
immediately answered no. But then, having gone away
and thought for a time, I felt I should have replied with
a measured yes.

In Martin's portrait, I saw an emphasis on Dido's
subordination — her positioning in the background,
her service bowl. She seemed fixed in the tradition of
lady's maids, footmen, and slaves, and reflected the same
contentious visions we've always had of such figures.
But as I came to know more of her life circumstances,
I understood that on some level what her image also
represented, beyond her physicality, was the sometimes

obscuring nature of visibility itself. Here was a woman who, though uneasily, moved through aristocratic England in an era that some even today insist on viewing as culturally homogeneous. As jarring as certain elements of her portrait read to the twenty-first-century eye, the tension between what we see, and what she was, forms part of the Western legacy. While we may not generally care for certain paintings, in the end they are all we have. Their essential truthfulness or dishonesty is also a part of our shared inheritance: they allow us a view into how people were seen, and so implicitly they show us how far we have come, or not come, from such ways of seeing. Dido's portrait dredges up questions of how human migration, both forced and chosen, has shaped the West for centuries. In her inescapable gaze, she seems to say, we have always been here.

3

IN 2007, I TRAVELLED from the south of Germany to Strasbourg, a stark but picturesque city just over the French border. My companions on the trip were two visual artists, all of us fellows at an arts academy and all of us foreign. Jorge was from São Paulo; jackie was a New York installation artist whose project was to build a house born from the imagination of Herman Wallace. Wallace, along with Robert King and Albert Woodfox, was one of the Angola Three, and had been held in solitary confinement at the Louisiana State Penitentiary for

over thirty years. jackie had spent more hours talking with Wallace than with her most devoted boyfriends; he was the repository of intimate knowledge even her closest friends did not know. And she, too, became for him a way to live.

At the academy, jackie had been sawing and hewing and piecing together a reconstruction of the cell in which he spent his hours, a wooden cage whose space she filled with a rich, sonorous recording of Wallace's voice. In a calm, unemotional tone, he described his idealized house, room by room. He spoke of a home basic in its comforts, with none of the showy luxuries of middle-class striving, but one that instead took nothing for granted — the simple dignity in a clean sink, the miracle of windows, free passage from a grassy backyard into a warm, bright kitchen. It was to be made a physical reality in New Orleans.

jackie had brought us to Strasbourg; it was she who'd rented the car to attend a friend's art show, and she wanted company on the drive. Jorge and I were happy to tag along, relieved to escape for a weekend the beautiful but isolated hilltop castle in which we lived, with its uncanny feel of a Thomas Mann novel. We were excited to see the German countryside, the impossible greenness of its fields, to feel the warmth from the open windows on our skin.

Strasbourg, when we reached it, was strange, cyclical. The roads with their dark cobblestones had the logic of a clock's gears, so that we constantly had to retrace our

route. Aiming to visit Our Lady of Strasbourg, we drove
street after twisting street, the cathedral moving away
from us despite our attempts to reach it. Finally we gave
up, and went instead to a bar. I remember the waiters'
excitement at my skin colour, their insistence on know-
ing where in Africa I was from. When they serenaded
me with Serge Gainsbourg's "Couleur Café," I was less
offended than amused by their earnest obtuseness.

The show was held at a small private gallery celebrat-
ing the work of several new artists. jackie's friend was
a petite, dark-haired woman in a low-cut cocktail dress
and sharp red heels. "I always forget how tiny you are,"
cried jackie, embracing her friend before turning back to
us. "Can you believe all she eats is red meat?"

This seemed unlikely, for the simple reason that no
young artist could ever afford such a diet. I think now
that the woman must have been a sculptor, though so
many years have passed that I can't be certain. Actually,
when I think back to that night, I hardly remember the
woman at all, but rather one of her fellow exhibitors — a
tall, ropey, unprepossessing woman who lingered in
a corner beside her own paintings. What struck me,
beyond her obvious physical anxiety, her wish to be
sucked whole through the floor into a realm with-
out judgements, was that her paintings were all the
same. Yes, the canvases were different sizes and differ-
ent hues; they had different textures — some thickly
painted, some watercolour-thin — and their back-
grounds had different colour values, but they offered

the same subject in the same pose, over and over. And the image itself was striking: a Black man wearing a strange combination of eighteenth-century European dress and a white turban, clutching a cane tipped with an emaciated lion. It would seem an odd subject for her to paint even once, I thought, never mind one to obsess over. I asked her about it.

To my surprise, the painter was not at all evasive, but spoke as if grateful to be asked. Some years ago, she said, she'd gone to a show at a gallery in a foreign city and seen the original image. Rather, it was not an original, but the most famous version of it, a mezzotint made by the German artist Johann Gottfried Haid that he'd based on a lost portrait by another German artist, Johann Steiner. The woman did not know why it spoke to her more than the other pieces in the show, only that she could not take her eyes from the clarity of the man's gaze, the jarring nature of his clothes. This act of looking had kindled in her a years-long passion. The object of her obsession, the man in the turban holding his cane with its lion, was called Angelus Solimanus, or Angelo Soliman. And although he'd led a remarkable life, it was his death that she could not let go.

THOUGH WE THINK OF THE AGE of Enlightenment as a great flowering of progressive ideas, a time when rational, secular, universalist values grew more widespread, the era also gave rise to pseudo-scientific racial theories

that are still with us today. Many of the Enlightenment's most revered thinkers, figures like the philosophers David Hume and Immanuel Kant, sought to classify and rank human difference, studying the perceived anatomical inferiorities of "other" races. One of the unexpected consequences of this new general scientific interest was that a small number of Africans who'd been deemed remarkable gained a certain fame, and that fame resulted in them having their portraits painted.

Angelo Soliman, whose given name was Mmadi Make, had been taken as a child from Borno State (now in modern Nigeria) and brought to Europe through a Spanish slave-trading route whose terminus was Messina, Sicily. He was purchased by the *marchesa* of a local aristocratic family and renamed after Suleiman the Magnificent, the conquering Ottoman ruler. It is said he began to call himself Angelo after falling in love with another servant in her household, a girl or woman named Angelina. If true, I imagine, to him, this was an act of self-creation, a way to assert some measure of control over his own identity. The *marchesa* saw fit to educate him, and in 1734 she would eventually present him as a gift to an Austrian prince who was the imperial governor of Sicily, and whom Soliman would accompany on the battlefields of Hungary and Bohemia as a favoured companion and valet. When the governor died, Soliman was sent to Vienna, to the household of Joseph Wenzel I, prince of Liechtenstein.

By all accounts, Soliman was a deeply respected and

beloved presence at court. He was highly educated, and as a polyglot he moved easily through the intellectual and artistic circles of Vienna, counting among his aristocratic friends the Austrian emperor Franz Joseph, with whom he played chess. Soliman acted as royal tutor and Prince Wenzel's chief servant. In 1783, he joined Zur wahren Eintracht (meaning "To True Unity"), the Masonic lodge whose members included Joseph Haydn and Wolfgang Amadeus Mozart. Zur wahren Eintracht's records show that Soliman and Mozart met many times at the lodge; it is assumed that Soliman was the basis for the character Bassa Selim in Mozart's opera *The Abduction from the Seraglio*. Soliman would eventually become the lodge's grand master, overseeing its evolution to include more scholarly aspects.

It was within the prince's exclusive social circles that Soliman first met Magdalena Christiani, a widowed noblewoman and the sister of a French duke who was a field marshal for Napoleon Bonaparte. She became Soliman's wife. Their only child, Josephine, would come of age to marry a prominent Viennese aristocrat, so the family's assimilation and their adjacency to power would seem to have cemented their status as fellow elites.

IN JOHANN GOTTFRIED HAID's portrait, Soliman appears regal and confident, one hand tucked gently into his waistcoat in a pose commonly used to convey dignity and decorum. His skin is very dark, and his eyes are

large and round and lit with a clarity that sets them aglow in his face. He is handsome and self-assured, and his placement against the storm-blackened sky almost suggests he is mounted on a horse. These are the Europeanized aspects of the portrait, and they are used to suggest the rational, the civilized. But there are other visual cues: the lands behind him are dotted with the pyramids and palm trees of Africa; the walking cane in his right hand is tipped with a golden lion; he wears, like Dido Elizabeth Belle in her portrait, a bright white turban, its folds immaculately rendered, a stand-in for the "Oriental," the exotic. These signal his unbreakable link to Africa, to the world of the "other."

A year before Haid made his portrait, Bernardo Bellotto finished his own piece featuring Soliman, a scene in oils depicting the gardens of the Liechtenstein Palace (*Das Gartenpalais Liechtenstein, Gartenseite*, 1759–60). The painting typifies the naturalistic urban landscape portraiture of the age, with its large, open skies, its fine architecture centred, the bricks painstakingly detailed. Men and women in their finery ascend the stairs, and foregrounded to the right, by the stone railing, are Soliman and the prince. Astonishingly, though he would at that time have been thirty-eight years old and was of unremarkable stature, in Bellotto's portrait Soliman stands the height of an average five-year-old, coming just to the prince's elbow. Despite being outdoors, he holds in his hands a tray of baked goods and a glass of water for his master. On the prince's other side sits a

dog, also gazing in expectation at his master. The effect is entirely disempowering, Soliman's size and wide-eyed subservience suggesting a permanent state of childhood, the eternal "boy."

How others perceived Soliman was clear, but we do not know how Soliman saw himself, or his adopted home. Was Europe for him the navigation of an enforced set of customs, or did its cultures feel more naturally inherited, despite the brutal circumstances of his childhood arrival? Who did he see as he passed through the long halls of Wenzel's castle, what image was cast back to him by its dim mirrors? Did what he saw feel authentic, or merely the one version of himself allowed expression among his many selves? Soliman's theatrically embroidered clothes were partly self-chosen, but Prince Wenzel insisted on dressing him as well, and on special occasions he would have Soliman wear gold and silver, velvets and silks and sabres. What were Soliman's thoughts as he wound a clean white turban about his head; what did he feel as he seized in his fingers the cane tipped with the fierce golden lion? Perhaps there was a distinction between what Soliman chose for himself and what was laid out for him. Perhaps his clothes were a small way to exert the little power he possessed, to assert his identity. Or, in giving physicality to fantastical notions of the exotic, could he not shake the sense of being a symbol?

What *is* clear is that, to Wenzel, Soliman was something more valuable than a man. He was one of the

luxuries of court, the blood-and-bone embodiment of a lifestyle whose excesses were paid for by money made from the labour of people like Soliman.

It is the details of Soliman's death rather than those of his life for which he is most remembered. These are the facts that most horrified the painter in Strasbourg, so that she could never forget him.

On November 21, 1796, Soliman died of a cardiac incident, either stroke or heart attack. A Christian burial would have been the expectation. Instead, after his death mask had been taken, Soliman's body was skinned and his skin used to cover a wooden frame in the shape of a man. His mannequin was put on display in the exhibition room of the Austrian Royal Natural History Collection, in the cabinet of curiosities. The body stood with one foot drawn back, his left hand outstretched. On his head he wore a crown of ostrich feathers, and on his waist a matching belt, the plumage red, white, and blue. His arms and legs were strung with white glass beads, and from his neck hung a delicate strand of porcelain snails.

Soliman's daughter, Josephine, made several frantic visits to the authorities to argue for the return of her father's body. Her pleas went unheard. For over fifty years, Soliman continued to stand in the cabinet's artificial Eden: tropical woods and shrubbery had been placed there, with fake streams running through them, and all about him were the animals of nature: muskrats, a tapir, a capybara, American marsh birds and songbirds. All of

Viennese society, Soliman's former friends and fellow courtiers, could come and view him at their whim in this idyll. His final release came only by chance, during the October Revolution, when the museum burned to the ground.

SEEING THE MANY VERSIONS of Soliman's portrait in Strasbourg, I wondered how the act of facsimile might distort what is being looked at. A white woman in the twenty-first century was painting iterations of a portrait by a white man who'd made a mezzotint of a painting by another white man of a Black man in eighteenth-century Europe. There were so many layers upon layers. I was reminded of a story my father told about finally leaving his parents' farm in Ghana to study in America, only to be placed by a government program for African students on another farm in upstate New York, and after asking for a transfer, on an even more remote farm farther north. He was living out the nightmare of Nietzsche's Eternal Return, his energy cycling through the same sequence of experiences. These many paintings of Soliman with their different authors — they too had something metaphysical about them, the recurrence across time and space. But what had been lost in this passage from one world to the next, what truths? As in a hall of mirrors, perhaps only distortions were possible. Looking at the Strasbourg portraits, I wondered if they had any correlation with the man they so lovingly depicted. If Haid's mezzotint, if

Steiner's oil portrait, if Bellotto's garden scene had gotten anything close to the truth.

4

IN THE SPRING OF 2015, I found myself in Brooklyn, with a few quiet hours to myself. It felt, to me, a strange time to have arrived in the city — two weeks earlier, a police officer had been indicted by a grand jury for shooting twenty-eight-year-old Akai Gurley. I had been reading about it, and it coloured my sense of the city. The shooting had occurred in November of the previous year: Gurley and his girlfriend had entered the ill-lit stairwell of a public housing building. An officer standing fourteen steps above was startled, and in his fear he shot into the darkness, his bullet ricocheting off the walls and striking Gurley fatally in the chest. Though the officer's charges would later be downgraded, and he would go on to serve house arrest and community service, the indictment brought an outpouring of rage, grief, disbelief. Some thought it unjust that he should be indicted at all — that, as an Asian man, he was being punished as few white officers had been punished. Some were relieved the police were finally being held accountable, though they doubted very much whether anything would truly come of it. It was a messy, chaotic, awful story, one full of suffering, a story Gurley's family would have to live with.

My thoughts troubled, I wandered into the Brooklyn Museum, its halls bright and warm after the

tire-blackened sleet outside. The air smelled of freshly laminated paper. The floor creaked companionably beneath my shoes, and I felt my frayed nerves calming. I entered the exhibition hall and was startled at the sight of a Black man lying in a field of wildflowers on a covered mattress, dressed in a modern ball cap and scruffy jeans, his eyes filled with divine if unfocused intensity. There was something so incongruous about the image, a tension between the figure's rapturous pose and expression and his stark modern clothes, that I was driven immediately back into that gallery in Strasbourg, into the sense of unreality the repeated images of Soliman had left me with, the grand artificiality of it.

It seems impossible now that I had not heard of the artist Kehinde Wiley. He had for many years been at the forefront of a disparate movement of artists pointedly taking charge of their own representation, their work a response to historical representations of Blackness. These artists have stressed self-definition and self-creation by taking themselves or other racialized people as the focus of their art, and they are exploring Black histories on their own terms.

It goes without saying that this project has sometimes proved controversial. When the Chicago artist Harmonia Rosales unveiled her piece *The Creation of God* in 2017, there was a public uproar. The painting was a re-envisioning of Michelangelo's *The Creation of Adam*, the fresco on the ceiling of the Sistine Chapel. In Rosales's version, God is a Black woman. Michelangelo's

image is one of the best known and most widely rein-
terpreted in the world — reproduced on keychains and
coffee mugs, parodied on television and in kitsch. But
Rosales's interpretation struck a nerve, and at the heart
of the outraged response seemed to be the feeling that
some sacred cultural inheritance had been violated.

Kehinde Wiley is arguably the most famous artist
working in this mode. He is today celebrated for his
presidential portrait of Barack Obama, though at the
time of my trip to Brooklyn, his most renowned paint-
ing was a take on a neoclassical portrait of Napoleon. As
I walked the galleries mounted with his vivid and highly
naturalistic paintings, I was struck by the angularity of
his subjects — quite often solitary men, lean and lightly
muscled. They wore contemporary streetwear — hood-
ies, sweatshirts, baseball caps, Timberland boots — and
stood in poses suggestive of, if not outright drawn from,
the representations of powerful men in old portraiture.
The elaborate backgrounds stood in forceful contrast
to these strong forms: they were detailed and ornate,
fussy and sometimes distracting. Intricate patterns of
flowers and vines; bright smatters of tile: they were,
I learned, based on sources as diverse as Renaissance
tapestries, Victorian wallpaper, baroque textiles. By
placing contemporary Black men in roles associated with
aristocratic Europeans, Wiley subverted the symbols
of power.

But there also seemed to be something more urgent
at play — something lacking in the portraits of the

Strasbourg painter, the void that made her work so much less rich, if memorable. Passing wall after wall of Wiley's work, I couldn't shake my sense that in every Black and brown face, in the grandeur of every expression and every pose that evoked Velázquez, Gauguin, Caravaggio, what I was really seeing was a plea to have an essential humanity acknowledged. The vivid physicality of his subjects, their skin lovingly burnished and glowing with health, asked us to consider the source of that vitality, the beating heart, the thrumming blood. These were joyful, furious, anxious, lustful, jealous, terrified, generous people. Their humanity was without refutation. The ripped jeans, the T-shirts of these divine figures might be the clothes of Akai Gurley, of Michael Brown, of a beloved uncle or son. They might, in our day, be those of George Floyd. What can be deified can also be killed; what can be celebrated can also be toppled. Our social hierarchies, our hatreds and divisions, are constructs awaiting dismantlement. This is the Western world as we have built it, Wiley seems to say, and it can be changed.

WILEY WAS BORN IN 1977 in South Central Los Angeles, the son of an African American mother and a Nigerian father he didn't know until adulthood. He was the sixth of his mother's children, and a twin. The family was very poor, living off welfare cheques and the meagre income from his mother's sidewalk thrift shop, until she earned

her teaching certification. When Wiley was eleven, she enrolled him and his brother in a children's art class. Wiley was so taken with art, and so naturally talented, that the following year he left for Russia to study painting. It was, it seems, a serendipitous place for him to have gone. Russia has a long history of portraiture, and it was in fact one of the last countries to abandon the "grand-manner" style celebrating the aristocracy.

In an interview with the *New York Times*, Wiley said:

> I started doing self-portraits. These horrible, aggrandizing ones in which I would place myself in the role of the noblemen that I would see in the museums. On the weekends, we would go . . . and we'd be enthralled by these strange portraits of people with powdered wigs and pears and lapdogs. And there was something really alienating about that vacuum-seal sense of history and ego. But at the same time there was something very familiar about that pomp, about the vulgarity of it all, that sense of them wanting to be seen for all eternity . . . I started pushing that narrative to be less about myself and more about the world, about the community that I grew up in, specifically about Black men in America. So, in a strange sense, it's a type of self-portraiture. It's about looking at people who happen to look like me.

I fully understand that feeling of duality when viewing old portraits: the hypnotic draw of their beauty contrasted with the alienation from the worlds they

represent. Wiley describes his project as one of inter-
rogating the very idea of the master painter while
recognizing his own complicity in this role. In this
way, his paintings feel at once historic and bombasti-
cally futuristic. Their power lies in the polar attraction
of these clashing elements.

Before leaving the museum, I stood a long time in
front of *Napoleon Leading the Army Over the Alps*. It is
the painting for which Wiley was best known before
his Obama portrait, and though it isn't necessarily his
most arresting, there is a quality from which you cannot
turn away. It is a play on *Bonaparte Crossing the Alps*
by the nineteenth-century French neoclassical painter
Jacques-Louis David. I would later learn that, as with
the Strasbourg versions of Angelo Soliman, *Bonaparte
Crossing the Alps* is also a story of layers upon layers.
David made not one but five variations of the image
between 1801 and 1805. The portraits are strongly
romanticized, with an utterly clean, commanding, heroic
Napoleon rearing back on a horse that's equally immacu-
late, despite the fact that he is galloping through the
Great Saint Bernard Pass. Though each portrait presents
a similar image — it is always Napoleon seated regally
on the back of that dangerously anxious horse — the
details shift and change, giving them the feel of a story
told across a period of years in which different meanings
arise. In the original, which the king of Spain took with
him into exile in the United States and which remained
there until 1949, Napoleon wears an orange cloak, and

his horse is black and white. The second version hung outside Paris in the Château de Saint-Cloud, and was saved from the wreckage when the château was destroyed in 1870 during the Franco-Prussian War. In the third iteration, which was spirited away during the Bourbon Restoration and now hangs in the Palace of Versailles, the steed's pelt has been darkened to grey. The fourth version was stolen from Northern Italy by the Austrian army following Napoleon's final defeat, and hung at the Belvedere palace in Vienna. David kept the final version in his possession until his death, and it had many homes before joining its predecessor at Versailles. By then, the horse had become black and white, but the most startling change is that Napoleon is finally old, his hair cut short, a tired, resigned smile on his face. Like highly skilled versions of the Soliman copies, the Napoleon paintings gesture towards the mutability of history, the ways in which our collective and personal stories are constantly shifting, re-evaluated and judged from the vantage of a changed morality.

Standing before Wiley's version, one feels a natural recoil, a desire to step back, as if some obstruction were suddenly placed there. A young Black man takes Napoleon's seat on the rearing horse, a look of weary confidence on his face. He wears a camouflage shirt and pants, a bandanna masking his bronze forehead, his shoulders gloriously draped in a gold cloak. The horse is the black-and-white horse of David's final version, with the same gaping mouth, its large eye rolling back

in terror. Instead of the distinctly European setting of the Alps, the background has become a tapestry bright as freshly let blood, imprinted with a bold golden pattern. The rider's expression is casually assertive, and he extends his right hand towards the sky in a gesture of conquest.

Interestingly, Wiley tried to use a real horse as a live model for the painting, but he found that the proportions between horse and man in David's originals had been skewed. David had enlarged Napoleon's body to stress the statesman's dominion and power. In a more honest version, the horse's body would have dwarfed Napoleon's, and not just because of the latter's diminutive stature — nearly every man looks small on a horse. (Actually, in an even more honest version, the horse would not be a horse at all — Napoleon had been mounted on a much less glorious mule.) Paintings of public figures in David's era (and some would argue in our own as well) were as much propaganda as artistic display, reinforcing ideas of all-powerful men able to dominate even nature.

There are those who might argue that Wiley's work is its own kind of erasure. That by replacing the white faces of European and American history with Black ones he is trying to demolish a legacy that though exclusive is unchangeably authentic. But this argument would seem to miss the point. Wiley's work is not literal. Rather, what it does is ask you to consider who has been expunged from the accepted narrative. How much does seeing *Napoleon Leading the Army Over the Alps*, or *Rumors of*

War, Wiley's statue in response to Confederate monuments, make you wonder about the historic probability or improbability of it? What were the assumed and actual roles of Black people during that period in history? How true are all our writ-in-stone stories?

Despite Wiley's seeming ideological engagement, he stated in an interview: "Artists are here to record the stories of our hearts, not our political stories, but rather our interior stories, so we're apolitical." Given his oeuvre, this may seem a kind of moral side-stepping, or even disingenuous. But I understand the instinct to shy from the fray. An artist has to feel they have the latitude to explore the issues and themes closest to their lives without feeling forced to take up the mantle of the spokesperson. In Wiley's case, his seems a refusal to be perceived as trafficking in the propaganda so central to the grand portraiture of artists like David. His desire is for a purely aesthetic assessment — because first and foremost Wiley's project is about exploring a beauty that has rarely been expressed in Western portraiture. But that becomes, for better or for worse, a political act when those societies have not outlived, or even fully acknowledged, their legacies of erasure. To ask us to re-envision history is to urge us to weigh newly unearthed threads of the story. And maybe that act can change the story.

5

IN THE SUMMER OF 2020, the Uffizi Galleries in Florence hired arts educator Justin Randolph Thompson to deliver a series of online lectures about Black figures in Old Master paintings. Thompson was to discuss eight artworks featuring people of African descent, painted between the fifteenth and eighteenth centuries. Sadly, though perhaps predictably, the initiative sparked a protest by far-right groups. Crowds marched through the streets of Florence with lit flares, unfurling banners with slogans like "Hands Off Our Heritage!" Online, the invective poured in: "Pathetic and ridiculous," wrote someone on Facebook. "Reinventing history in the name of political correctness," was another comment.

What the protesters likely had not grasped is that the paintings in question were already part of the permanent collections of the Uffizi and its sister museum. They had not been specially brought in for the talks. (Whether the pieces were on permanent display or in storage I do not know.) The lectures were not, as the protesters believed, an attempt to rewrite Italian history, but rather were an unearthing of it, an airing of what had literally always been there. Thompson wanted to challenge the idea that historical paintings are purely the legacy of white Europeans. He included such pieces as Piero di Cosimo's *Perseus Freeing Andromeda,* which depicts a Black female musician, as well as portraits of Duke Alessandro de' Medici, who ruled Florence and its territories from 1532

until his assassination in 1537. Known as "the Moor" because of his darker complexion, Duke Alessandro was the son of Lorenzo II de' Medici and an African servant in the Medici household.

Thompson said he'd found "a certain reluctance towards acknowledging the existence of Black African royalty" in the age of the Renaissance. "Any conversation about Blackness in that space is a challenge to the existing order."

Similarly controversial was a 2019 exhibition at the Musée d'Orsay in Paris. Called *Black Models: From Géricault to Matisse,* the show took masterpieces by some of France's most celebrated artists and debuted them with new names. The paintings were all renamed in honour of the Black subjects depicted in them. The idea, I think, was to remind the viewer of the indelible presence of Black people in France for centuries. The curators were attempting to put paid to the lie of a purely white France only recently changed by mass migrations; they wanted to show that no aspect of Western development happened without the hand of the "other."

As an example, Marie-Guillemine Benoist's *Portrait of a Negress* was renamed after the model depicted: *Madeleine.* In reclaiming her name, the subject was to regain some measure of her humanity.

I am of two minds when it comes to this kind of restitution. Though I understand what a powerful act naming is, and the impulse to reframe and re-contextualize things for our time, I understand too how certain historic

resonances can be lost. In the case of older portraits, the names were often not artist-given: they were bestowed after the fact by vendors and gallerists and curators, and may not have reflected the artist's intention. This might be the case for Benoist's *Portrait of a Negress*, and if that is so, I wholeheartedly support the change to *Madeleine*.

In the case, though, where the name was chosen or sanctioned by the artist, things grow a little thornier. But it seems to me that while original titles may carry within them the distasteful and accepted prejudices of the worlds in which they were chosen, they force us, in their offense, to look hard at the social climate and circumstances of those worlds. I do not at all care for Joseph Conrad's title *The Nigger of the "Narcissus,"* but I could not imagine the novel being called otherwise. It bears witness to the ugliness of a time and mindset in which such epithets were an accepted and neutral thing.

Perhaps one solution, in the case of visual art, would be for the work to bear both titles, an "original" and a "contemporary" one. The gulf between them would say much about the past and about the progress we've made, and how much farther we have to go.

We too will be judged, and judged harshly, by those who come after us. We cannot know now how we will offend. But our offences will become the yardstick by which future generations can measure themselves.

IN THE FIRST WEEKS after her arrival in America from Ghana, my mother was given a sketch of herself. It was drawn by an acquaintance, one of those friendships of desperation made in the first weeks of university that are so fleeting and burn out so quickly. The girl was a mathematical genius — truly, she was a wonder, never studying, processing elaborate equations in her mind's eye — but she was also a casual artist, and she would sit among her peers deep in their books and draw them.

The friendship did not last, but the sketch has, these fifty years. In it, the artist reveals the kind of delicacy and precision of feature that only distanced consideration can capture. She managed to convey the gentle mournfulness of a face still finding its form, the prominent nose and sharply cut cheeks, the self-consciousness of being looked at, all my mother's fearful and burning ambition somehow softened. My mother still seemed to be looking out beyond to an imagined world across the Atlantic, despite the fact that she had already arrived.

That was one version of my mother, and no doubt it was a true one. But it was also one constructed by the subjectivity of its maker, and by my own wish to view my mother that way. I recognize that I bring to bear on the picture all of my love and my frustration with her, my longing and irritation and fear. I am as much a subjective portraitist in the describing of it as her friend was in the drawing of it.

But I do this with an understanding of her many struggles to adapt: America might have been a new planet for all its familiarity. The food was curiously heavy and bland, meat and bread and endless cheese; her accent felt thick in her mouth, so much did others struggle to understand her. Once, she sat injured for an hour on a sidewalk while passersby turned their faces away at the sight of her coursing blood. Those were features of her new America, too. But she also felt wonder at the swift efficiency of the mail; at the clean order of supermarkets with their precut packaged mushrooms and their blazing, infinite light; at the glow of a snow-filled sky, the white-ness of ice-bound trees. All this was alive in her. None of this was captured.

Of my own portrait by Hartman, I often hear that I look sad. Not thoughtful, not distraught: just a little melancholy. Some have expressed gentle perplexity at this, thinking it unlike me, while others are astonished at how clearly my essential character has come through. Each commenter knows me well, and yet each still seeks to understand the quality of despondence made visible by Hartman's eye. I accept that, should this portrait survive, what others see many years from now will not be how I understood myself. I will be given new meaning, a life beyond life.

Looking at portraits from long ago, the things ghost-ing those images do not feel so very different. Even if we know something of the sitter's history, our gaps in perception drive us to imagine her innermost private

thoughts. Portraits offer a glimpse into another's existence, one that might not be true, but that could be true. We look upon these faces estranged by time, and we want in a meaningful way to know them. Did Dido Elizabeth Belle feel bereaved at being treated differently from her cousin? What were the wishes she had for her life, and was her freedom anything like she'd expected it to be? Why is Wiley's Napoleon so wary? What were the tasks that remained undone because of the sitting, where did he go afterwards, what did he regret? Did Angelo Soliman feel any presentiment of his death and eventual release? Did he startle awake in the coldness of his room, shaken by dreams of fire?

To look at a portrait is to be forced to build a human life out of our own imaginations. That is what makes it a fundamentally hopeful act. Every portrait is a plea, at its heart, for empathy. When we sideline or hide away images of certain people, what we are cutting ourselves off from is some sense of their possible history and daily lives, their humanity. The lingering fascination of art, its power, lies in our ability to make whole what is lost, through dreaming. A fixed image can be an entire life, a flowing story. We ask, who *were* they — or in the case of invented people, what were their possible lives? And in the answering, we wade back towards them, to their essential mystery, which is the same mystery we each of us are now living out, the morality of our choices, the worth of how we've spent our limited hours.

CHAPTER TWO

CANADA AND THE ART OF GHOSTS

1

MY FRIEND'S PARENTS RETIRED to a homestead in north-ern Alberta that they called, simply, "The Farm." It was a great rambling estate of some hundred acres with bright rolling grasses, a handsome barn-style home, and a building they christened "The Shed," though it was actu-ally a sprawling complex, its high metal walls housing his father's car collection, no fewer than two hundred models. My friend was a generous soul, embarrassed by his family's wealth. One summer he invited me up for a weekend at The Farm. We spent sun-filled days racing on ATVS, eating fresh apricots, plums, and wild strawber-ries pale with dust from the brambles, swimming in the man-made lake in the clear hours before the mosquitoes thickened. In wintertime, that same lake hardened to a

gleaming blue sheet that drew skaters from as far, he swore, as Edmonton. Through the snow-glazed window of The Farm's kitchen, you could hear the brisk, hissing sounds of their blades striking the ice.

But summer was The Farm's most beautiful season. Our weekend was one of lazy contentment, as if we knew we were exactly where we were meant to be. We sat around dinners laced with overripe tomatoes, the sun sweet in their flesh, talking late into the night about other places, other times. My friend's getting lost in the winding, brightly painted streets of Goa. My tarot reading in a narrow alley off the Campo de' Fiori in Rome. Years later, I was surprised to hear The Farm had been sold.

"Did your parents miss city life?" I asked.

But that wasn't it. What happened was altogether stranger.

It had started simply, incrementally. After a morning in the city, they had returned in the late afternoon to discover the furniture in the living room had shifted slightly. They could just make out the impressions of the furniture's feet in the carpet's pile, an inch to the right. They thought nothing of it, simply nudged everything back into place. But then it happened again, and then again. They called in a friend who worked construction; he could find nothing awry with the house.

Then events started occurring when they were home. My friend's mother was in the habit of marking her page in a book with her reading glasses. Rising to pour herself

a cup of water at the sink, she turned to discover the glasses gone. She found them in a far-off guest room she rarely entered. Picture frames on desktops and dressers were often found overturned, lying face down. Once, as she sat in an easy chair with a crossword in hand, her back to the window, she heard the venetian blinds rise up two slats, slowly and deliberately. She lurched from the chair. The cord on the blinds was still swaying.

They tried to explain it away. Wind, tremors in the earth, forgetfulness.

But one evening in February, their tolerance reached its breaking point. Returning from a movie in Edmonton, they parked on their snowy gravel drive and climbed the stairs. The hall light was not working. They tried another switch. Nothing. Another, and again, nothing. My friend's father made his way out to the garage, where by flashlight he flipped every fuse in the house. He went inside to find his wife still in the dark. He took her cold hand, went into the living room, and raised the flashlight.

Every lightbulb in the house had been unscrewed and piled neatly in the middle of the rug.

THERE ARE THOSE FOR WHOM this story will always be a fiction. The belief in ghosts has never been universal, coloured as it is by religious faith and spirituality, by culture, science, and even temperament. For some, a ghost cannot withstand its unlikeliness. To others, there

exists the world of the living and the world of the dead
and yet a third one, a nation in between, whose citizens
are unseen but whose hold over us remains visceral;
these are the ghosts of our primal terrors. But there
are other, more crucial ways we are haunted, ways that
require no deep belief in the occult.

And they are less easily shrugged off. One might
argue that ghost stories are trivial, merely something
to entertain around a campfire. But I believe they are a
central way we build our personal and cultural myths.
The stories we tell about the dead act as clarifying narra-
tives to explain what has shaped us, and what continues
to make us who we are. Part of their work is to establish
context. They connect us to what has lived on the land
before us, to people and animals, to all that precedes us.
They lessen our sense of solitude in the world by offer-
ing the possibility that death is not death — that human
life is so powerful and exceptional it can will its own
continuance and populate an entire shadow world still
intimately connected with our own.

Ghost stories are at their core repositories of our
pasts — both our personal pasts and our public, collective
ones. Though we tend to think of them as a compen-
dium of our fears, of our terror at the many open-ended
things that scare us, they are also a haunting of another
kind. A ghost story is as much an inversion of the things
we cherish in life as it is about the things that frighten
us. It is, by its nature, an excavation. To acknowledge
the existence of what has come before us is to burnish

past lives with importance — it is to say, in effect, that people's passage through this world is of consequence and remains unforgotten.

Tales of ghosts are some of the oldest stories we have, and they span every culture. Because of the central place they hold for us, they tend to shift with the telling, with the generations, becoming in every age whatever we need them to be. When I was a child, a story made its way around the playground about the woman with the black ribbon. She was newly married and wore a black ribbon around her neck always. Despite her husband's curiosity, she refused to remove the ribbon or tell him why she wore it. One night, as she slept, he crept up on her with a pair of scissors and cut the black fabric. Her head rolled off onto the floor. For the rest of his life, she would appear every year on his birthday to torment him, luminous, untouchable, from another world.

The sexism was lost on my eight-year-old self; I saw only the punishment for a rash act, the easily digestible moral of being content with your lot. How surprised I was, during a casual conversation with the ninety-two-year-old grandfather of a friend, to discover that his generation had its own version of the tale.

"It's about Spanish Flu," he said simply.

How so?

"It's a Black Death story that my folks were told during the Flu years — the black ribbon means Black Death. People brought up the Plague a lot during the Flu years."

That generation's version had tied the present to the past through illness, and by expressing the many anxieties of contagion: fear of actual infection; fear of being stigmatized by carrying the black mark of sickness; fear of death; fear of the shadow that so much continuous death would cast over the younger generations.

The tale of the ribbon — sometimes black, sometimes green, sometimes just the texture of velvet — is said to have originated in France. It was popularized by an 1834 short story by Washington Irving, set during the French Revolution. In Irving's telling, a young German man living in Paris is on his way home one evening when he crosses paths with a woman. She is predictably alluring, and she wears around her throat a black ribbon held in place with a diamond clasp. He takes her back to his apartment, where, quite expectedly (and quite euphemistically), they fall fast in love. The next morning, after leaving her asleep in his bedroom, he returns to find her dead. The police are called: almost immediately, one of the constables recognizes her as the victim of an execution by guillotine he'd witnessed the day before. The story symbolized the instability of the revolutionary years and how they continued to literally haunt the French populace.

Alexandre Dumas's "La femme au collier de velours" is yet another version. The latest iteration I've come across is Carmen Maria Machado's "The Husband Stitch," from her 2017 collection *Her Body and Other Parties*. In Machado's re-envisioning, the couple is utterly modern,

navigating late-night arguments and child-rearing and a thrilling sexual life that is all-consuming until it isn't. The woman's narrative voice is frank and charming and of her green ribbon, she says, meaningfully, "Maybe we are all marked in some way." She gives gladly of herself in what appears to be a relationship of equals, but there's still the occasional expression of husbandly proprietorship over her body. The title refers to the stitching up of the perineum after childbirth. In the recovery room, her husband asks if the doctor might put in an extra stitch, to render their lovemaking that much more pleasurable. While theirs is a story of sexual compatibility, it is also a story of male encroachment. When, in the end, the green ribbon is finally removed from her throat, the gesture at first sexually excites her husband, before the terror of her death sinks in. Despite how generously the narrator has given of her love, despite her husband's essential decency, it's this most ravenous of desires that has haunted their relationship: his burning need for her to surrender the one secret she'd fought to keep. Machado's version haunts us by gesturing towards our renewed fears about the control of women's bodies and reproductive rights, and also at the consequences of sexual refusal — current ghosts that are also old ghosts.

2

FOR THOUSANDS OF YEARS, the city of Edmonton and the land just north of it was a region of vast lakes and forests,

open plains through which passed the Cree, Tsuut'ina, Nakota Sioux, Niitsitapi (Blackfoot), and Saulteaux Peoples, among others. It rested between the wildness of the prairie and the stark dry hills, its lakes leading all the way to Hudson Bay.

In the early years of the twentieth century, freed slaves from Oklahoma and other Southern American states made their way north to the Alberta prairie. Nearly one thousand African Americans arrived, drawn by the possibility of liberation from the crushing Jim Crow laws of the South, and they tried, with much difficulty, to establish townships on the rock-strewn land they'd been granted.

The farm my friend's parents abandoned to ghosts lay in proximity to the lands the western Indigenous Peoples passed through, and it lay also within range of the Black township of Amber Valley. After the frightening goings-on in her home, my friend's mother decided to try to seek out the source of their haunting. She looked into the genealogical logs of the Latter-day Saints; she uncovered Germans who fled financial persecution in Austria and arrived in Alberta in 1889; she devoured histories about Ukrainians from the province of Galatia in the Austro-Hungarian Empire. She searched for murders among the Icelandic, for Mennonite and French Canadian suicides. Every wave of migration, she believed, would surely have its own deaths and burials. In this she was undoubtedly right. But I was struck by how little it occurred to her that her ghosts — in whose existence she was fully

convinced — might belong to one of the communities of colour whose presence also predated her own on the land. She didn't bother with the stories of those who were not, like her, descendants of Europe.

It seems a strange thing to speak about race when discussing ghosts. But it is interesting to note how often such details get left out. Unless race itself was a factor in the death, the race of a ghost is presumed to be the same as for the person telling the ghost story. This might simply be because ghost stories emerge from within cultural groups and act as a reflection of those groups. They are that group's private history. And because ghost stories are really about the living, not the dead, they reflect the paranoias of our own age, the values of our own culture, the concerns of our own nation. If confronted, for example, by the ghost of a Roman soldier, we would likely imbue him with our own notions of good and evil, rather than those of the old world to which he belonged.

There are two ghost stories my husband remembers hearing about at his high school. By the time he attended, in the early nineties, it was a pristine university school catering to young men and women, but it had been founded in 1906 as a school for troubled boys. One story takes place in 1948, and it is about a young rugby player, a prop, whose neck was broken when the scrum collapsed on top of him. He died later that night. Students began seeing him on foggy nights, wandering the pitch. Even during my husband's time, sightings of him were still being reported.

The other ghost is that of a Chinese cook who hanged himself in the bell tower during World War II. This would have been at the height of local xenophobia against the Japanese for their involvement in the war, and one imagines that any person of Asian descent must have been a target. His story is less often told. His ghost is said to be much more threatening, caught in a loop of seething fury, haunting the kitchens of Brown Hall with a vicious look in his eye. The serene, romantic figure of the tragic athlete; the angry, threatening Chinese cook — the discord between how each is viewed exposes how uncomfortably race plays a factor in how someone is memorialized. In both the cook's actual story and the commemoration of it, the listener must confront unsavoury prejudices, hatreds still so pervasive today they are both a living thing and a haunting.

3

IF GHOST STORIES REFLECT to us our histories, our yearning for a connection across time, who is being forgotten, and why? If people who have been marginalized in life are also excised from our tales of the dead, what importance can they claim in our greater collective story? If, in fact, we will into being the ghosts we so desperately need, what does the omission of certain ghosts say about the value we place on communities outside the mainstream?

In Canada, where the population of people of African descent has never exceeded 3.5 percent, Black ghost

stories are barely visible. This despite the fact that all across Canada, Black settlers arrived through all means of force and desire and necessity and built comparable lives on the land. Many lived on and cultivated homesteads, and many died on them. And yet ghost narratives in which Black people feature are rare, left out of the official record of ghost tours and local history books and podcasts and all the other ways we go about commemorating the dead who live. A recent book of collectible Hallowe'en stamps issued by Canada Post included the stories of Vancouver's Brakeman, Manitoba's Red River Resistance, Quebec's Marie-Josephte Corriveau, the Caribou Hotel in the Yukon, and Halifax's Citadel. An obvious attempt was made to represent the regions of our vast country; less so to express the full breadth of our diverse communities (Red River being the exception).

At the heart of ghost stories are deaths, sometimes violent: accidents, suicides, executions, murders. The deaths are usually unnatural — sudden or retributive — or, when natural, freakish. Unnatural death has, sadly, been at the heart of so many conversations about Blackness these past few years. But this is no recent, modern phenomenon.

IN VIEUX-MONTRÉAL, A WOMAN in white roams rue Saint-Paul. A sign marked "Arsonist" hangs from her broken neck. She drifts up and down the street, it is said, seeking vengeance.

She is the ghost of Marie-Joseph Angélique. She has been commemorated in plays, in histories, and on a plaque set into the public square across from Montreal City Hall. The square itself has been renamed Place Marie-Joseph Angélique. Hers is the rare death with which we have attempted a reckoning, but that reckoning points to still greater silences.

Angélique was born a slave in Madeira, Portugal, in 1705 and died a slave in Vieux-Montréal twenty-nine years later. Her short life held little grace. She had been sold in her native land to a Flemish man, who brought her along with all his other possessions to the New World. How strange New France must have struck her upon arrival. The very texture of the air would have felt different, its smells, its ungovernable cold. She was sold to a French businessman in Montreal, and after his death she became the property of his wife. Thérèse de Francheville was said to be cruel, in a time when cruelty was so common that the fact hers bore remarking upon suggests the extent of her awfulness.

When we speak of slavery, what usually comes to mind are cotton fields, sugar plantations, coffles, and overseers striking raw backs in the sweltering heat. Canadian slavery was different — and this fact, I believe, along with a lack of cohesive legislation on the matter, has allowed us as a country to overlook it. Black Canadian slaves mostly worked as domestics in households, and Angélique's fate was no different. She performed her duties as a maid in the de Francheville

home, serving meals and airing sheets, washing windows and polishing floors, travelling occasionally into the countryside to work on the family's small farm. During these years, she bore three children, all of whom were rumoured to have issued from forced breeding and none of whom survived past five months. That was horror enough for one lifetime. But hers was an unmerciful life, hard to the point of ferocity, with no luck to temper it.

The year before her death, Angélique fell into a romantic relationship with an indentured servant in the household, a man called Claude Thibault. Whether this was a love of convenience or a deeper one is not a matter of record, but she was attached enough to risk an escape. They waited until their mistress had gone away on business, leaving them at the house of her former brother-in-law. They set fire to his home and fled across the frozen Saint Lawrence River to seek their freedom in New England. But the winter was vicious and unrelenting, and they were forced to take refuge in Châteauguay. They were captured some weeks later by a militia searching the area, and were transported back to Montreal. Thibault was imprisoned. Angélique was seen bringing him food on her visits to his cold cell.

Angélique herself served no jail time, was simply returned, like a sweater or a book, to her mistress. But her transgression lingered in the mind, and Thérèse de Francheville had negotiated her sale to one of her husband's old business associates, who bought Angélique

for six hundred pounds of gunpowder. She would be sent north to Quebec City, as soon as the ice melted and the Saint Lawrence was passable by ships. As she looked with dread towards the spring, Thibault was released from prison and came to visit her several times when the mistress was away. They again made plans to escape, knowing that, once in Quebec City, Angélique risked being sold to the West Indies.

ON THE EVENING OF APRIL 10, 1734, the people of Montreal opened their doors onto a sky apocalyptic with fire and smoke. Flames raged from rue Saint-Paul east to rue Saint-Joseph, the heat so intense that firefighters could not close in on it. People scrambled into the Hôtel-Dieu, but the winds surged westward, burning the hospital to ash in less than three hours. Panicked crowds ran through the streets; countless houses were reduced to their foundations. It was a scene of such shocking destruction that it had something of the biblical about it, a quality of God's vengeance, of a smiting.

Almost immediately, rumours abounded that Angélique had set the fire. That she had done so to create a diversion so she could escape. These whispers were said to have originated with the slave of a neighbour, who claimed she'd overheard Angélique crowing that the widow Francheville would not "sleep in her house" that night. By the time the embers had died, nearly the whole of Montreal was convinced of Angélique's guilt.

When local officials tracked her down, she was wandering the ruins of the paupers' garden at the Hôtel-Dieu. We do not know what she said in that moment, though she would later deny all responsibility. She was taken to jail to await the filing of a formal charge. A warrant was also issued for her lover, Thibault, but he had entirely disappeared.

French law at the time allowed for arrests to be made based on evidence accumulated through public testimonies alone. Over the next six weeks of spring, several witnesses were called, but none had seen Angélique set the fire. They were all convinced, however, that she had done so. They gave statements about her terrible character and her penchant for arguing with her mistress. Even a five-year-old girl, Amable Lemoine *dit* Moniere, stepped forward to testify that she'd seen Angélique hauling shovelfuls of coal up into the attic of her aunt's home just before the fire started. That a five-year-old's credibility went unquestioned speaks volumes about how deeply the townspeople wanted to avoid being haunted by a lingering lack of answers, by the idea that one of their brethren might have been to blame, or, worse, that it had been an act of God.

Angélique was found guilty. She was sentenced to walk naked to the gates of the parish church with a noose around her neck, carrying before her a torch to symbolize the fire she'd set. She would then be forced onto a cart used for transporting the city's garbage and driven to the doors of the high court, where, holding the sign

reading "Arsonist," she would kneel naked in the mud and confess. She was then to have her hands cut off and fixed on a stake in front of the church. She would continue on in the garbage cart to the public square now named for her, where she would burn at the stake, her ashes tossed to the four winds.

In a terrible irony, she was sent north to Quebec City, the town she'd tried so fiercely to run from, where an appeals court reduced her sentence. She would no longer have her hands cut off or be burned alive but would be hanged, her body attached to a gibbet and burned afterward. As part of her lessened sentence, she was required to confess her guilt and name her co-conspirators through the use of torture. Returned to Montreal, she was delivered over to the seasoned torturer Mathieu Léveillé, himself a Black slave, who submitted her to what was benignly called "la question ordinaire et extraordinaire" — a structure of wooden boots to which an excruciating pressure was applied, crushing the legs. Angélique broke quickly under the pain and confessed, though she refused to name a co-conspirator, begging in the end only to be killed swiftly. She was hanged in the ruins of the city, and then burned.

SOME YEARS AGO, WHEN I was pregnant with my son, my husband and I travelled to Montreal as our final trip before the baby's birth. I remember standing in Place

Marie-Joseph Angélique, hoping to experience some-
thing of her presence, or at the very least to feel some
inkling of her energy. The sun lay like a fine dust on
the warm pavement, a smell of damp grass in the air. A
flurry of birds dove into and fled the square; well-dressed
people shuffled by, frowning at the phones in their palms.
In the end we felt and saw nothing.

The existence of Angélique's ghost is taken on faith,
as first-hand accounts of sightings are rare. The most
comprehensive one I've come across is a single line
in a Montreal student newspaper, which states that
Angélique's "spirit has been seen walking from east to
west in the alley adjacent to Place Royal, near St. Paul
Street." But it does not tell us what this account was orig-
inally based on, who first told it, how many had seen her
before or have seen her since.

Her ghost, it seems, is an absence we insist is a pres-
ence. I suppose this is the very definition of a ghost. But
in granting this particular woman a spectral afterlife,
in persisting with her mythology, we have made a point
of wilfully remembering her. She is part of our cultural
inheritance, someone we cannot turn from. But she did
not exist outside of the society she inhabited, and we
have been slower to make visible the failings of her era.

SLAVERY IS NOT ONE of the ghost stories of our nation,
but it should be. Its history does not haunt us, and even
today I'd argue the average Canadian knows persistently

little about it. When slavery does come up, for instance, in the curriculum, it is nearly always the story of the Underground Railroad, the guiding North Star and the townships of runaway slaves who found safety in our British territories. Please do not misunderstand me — our country's role as the terminus on that route to freedom is deservedly celebrated. But that particular narrative has always obscured earlier truths. Because of our privileging of that story, and also because Canadian slavery did not take on the familiar contours we associate with forced bondage — scorched days on a plantation, an economy based on the exploitation of indentured labour, essentially American and Caribbean contours — we tend to think it did not exist here. We feel secure in our role as the Promised Land, morally divorced from the ugly realities of racism and subjugation. But as historian Afua Cooper points out, "Canada might not have been a slave society . . . but it was a society with slaves. It shared this feature with virtually all other New World societies."

It is difficult to quantify the numbers when we look at Canadian slavery, though we know that many people of African descent were transported to Upper Canada (Ontario), Prince Edward Island, New Brunswick, Nova Scotia, and New France (Quebec), which had the greatest numbers, from the sixteenth to the nineteenth century. There is a dearth of scholarship, due mainly to the lack of primary sources such as the manifests of merchant ships from the Caribbean (many of those ships built in our own eastern shipyards). Scholars of slavery have

tended to focus on plantation economies, which arose in tropical or semi-tropical climates, and where slavery was undoubtedly more rampant, the backbone of the economy. Less attention has been paid to the evolution of slavery in temperate colonies where year-round agriculture was unsustainable. Add to this the fact that there was no across-the-board system of taxation that might have forced slave owners to account for their property, and the lives of Canadian slaves slip easily from our collective imagination.

What we do know is that in New France alone, there were likely close to four thousand slaves, including Indigenous slaves. About half of these slaves lived in or around Montreal, the rest in small towns beyond it. Because of this urbanization, few slaves worked in the fields or in mines, though some did; they were more often, like Angélique, domestics. None had anything like the limited agency of white domestics; in effect, they were the northern version of house slaves, subject to the whims of their masters. Some were born on the land and at Confederation were made Canadian along with the coasts; still others arrived as cargo on merchant ships, stored in the holds with other goods like molasses, rum, and sugar. These foodstuffs from the West Indies would be traded on Canadian soil for salted cod and other eastern staples.

Our ideas of pioneer life rarely seem to include the people of African descent who, both enslaved and free, built farms, homesteads, and roads, who hunted and

fished on the land and lived lives of spectacular diversity. Their deaths too would vary greatly in their means, and differ in their commemorative rituals. In the case of some slaves, death was the only aspect of life over which they or their loved ones could exert any control. For this reason, funerals were often approached with the delicacy of an art. Ritual songs were sung, and great pains were taken with the body, wrapping it in a shroud and adding to the coffin special objects of remembrance. Death was a door opening onto the homeland of the free, the kingdom of God. This made Black burial grounds, inadvertently, places of fleeting self-government, and therefore powerful sites of resistance. They offered one of the few means to establish a physical history that could not be refuted. The stories of the dead, too, are a graveyard, a monument of words. And yet, beyond Angélique, our slaves are not our ghosts.

4

BUT WHAT IF EVEN THE GRAVES could be destroyed?

In the 1830s, the town of Priceville, Ontario, was established by Black settlers claiming lots promised them by the Crown. Some had fought alongside the British in the War of 1812, and as payment they were granted the rich arable lands in the northern regions of Upper Canada. They named their new community after the first settler to turn earth there, a Black man called Colonel Price.

And yet, though they cleared the brush and erected the cabins and tilled the land, the land was never theirs. It had not been legally assigned or officially charted. Settlers on neighbouring properties, Scottish and Irish farmers who arrived some years later, began to force them out. When the Black community attempted to purchase their homesteads, they were deemed squatters by land agents unmoved by their cause. They saw their land parcelled off and sold, sometimes amid scenes of ferocious violence. In the end, nothing was left but the graveyard, the names of their dead chiselled into weather-pocked stones.

In 1930, the farmer Bill Reid was given possession of the estate on which the cemetery lay. Fully aware of the graveyard's existence, he sowed the burial grounds with potatoes. In *Speakers for the Dead*, a documentary about Priceville's history, Reid's daughter explains how their family "raised very good potatoes on that particular piece of land. They were excellent, they lasted well through the winter." Because Black cemeteries were not on lands legally designated for interment, they were denied protections under the law, and were therefore vulnerable to desecration. Another Priceville resident who was a child at the time vividly recalls the home plate of his schoolyard baseball diamond being marked with the name "Margaret." Explaining that he and the other boys used to jokingly call it "Maggie," he says that it was in fact a headstone from the Black cemetery. Other gravestones, it was said, were used as stepping

stones in Reid's flooded basement, or as flooring in his horse stable.

These were ghost stories, told in half disbelief. But many did not want them told, and drove them back into the shadows. Few felt free to speak them openly.

But the stories would not die; they kept surging up. Several Priceville citizens finally formed a committee to attempt to redress what could not be redressed but only reckoned with. They lobbied successfully to have the land, which by the 1980s had become a cow pasture, pass into the public domain. Collectively, and calling for the involvement of the Black pioneers' descendants, they looked for a way to re-consecrate the land, or at least make some gesture of reclamation.

The committee was alerted to the existence of an old letter, written in 1952. It spoke of the remnants of the "darkie" cemetery: they could be found in a pile of cast-off stones north of the school. And so, in the summer of 1989, a few members set upon the crumbling and forgotten rock heap on the schoolgrounds, and there they discovered the broken gravestone of a boy: Christopher Simmons, dead in one of the many epidemics that raged through the colony, buried by parents whose own names were chipped neatly beneath the month and year they had lost him.

Other stones were swiftly discovered. James Handy, James Washington, an Ellen whose surname had been obliterated by time and human instruments and the elements. Four in all. A world dredged from oblivion.

Proof after all that the ghost stories were anchored in the human.

This might have been the end of forgetting, or the beginning of a reckoning, but in this case the stories were buried unusually deep. Some residents called for a full excavation to restore the field to its original role as a cemetery. Others balked at the idea. Some wondered at the enormous task of matching DNA with the remains. Many seemed rattled by the idea that an unaccounted-for ancestor might be revealed as a part of the family tree: some of the white townspeople might be, in some measure, Black.

In the end, the excavation recovered nothing. But years later, ground-probing radar would reveal the presence of nearly one hundred graves. Today they lie in a small, empty, fenced-in field, beneath piles of rock.

·

THE STORY OF PRICEVILLE is the story of silenced ghosts. Part of the work of ghost stories is to create context — the context of inheritance, ownership, reclamation, but especially of belonging. To deny stories of the dead is to deny ourselves this context, which we use to make sense of the world they have given us. It is to desecrate our collective story.

The suppression of the Black settlers' presence, of the fact of their arrival and the details of how they lived and how they died, meant that Priceville could not even begin to create a mythology that acknowledged them.

Nor did it seem to wish to, at least initially. Because ghost stories rely on cultural touchstones, and because people can sometimes have warring agendas and refuse to agree on those touchstones, the lack of stories can become a powerful burial of the truth. Ghost stories allow the living to write onto the past the concerns of the living. They can be used to lay claim to the ongoing settlement of the land, to suggest a line of continuance that cuts others out. A past of which you don't speak can, in its silence, powerfully shape the present. The thing that makes ghost stories so urgent — their sense of continuity, the feeling of reaching across time — is also what can make them uncomfortably revisionist. Certain people are excised from the narrative; certain events go ignored. The dead we see are the dead we choose to see.

5

I ONLY ONCE VISITED my mother at her workplace, a seniors' home where she was a registered nurse. It was a sprawling building set low among bare trees, as if winter were eternal there, and inside, the wards were bleached white and smelled unpleasantly of bile and Dettol. I might have been eight or nine years old. I had a visceral fear of old people, a fear I'd often thought was cruel but that strikes me now as a common childhood defence against change.

I remember entering through the sliding doors, which eased open with a pleasant hiss, and blinking hard in the

greenish fluorescent light. Almost immediately I lost track of my father, who turned a corner and was gone. All at once, I was set upon by a breathless force, a presence surprising in its swiftness. It was some seconds before I understood what was happening. A woman stood blocking my way.

Her stare was like a grip. She was small in stature, her hair dyed a stark black, her lips trembling as if just on the verge of speaking. Her eyes had a sheen on them, though she did not appear to be crying. Abruptly, she turned and began to retreat down the hall.

I sensed I was meant to follow, but I just stood there, hesitating. Reluctant, I began to trail after her.

She went into the first room off the hall, a room smelling strongly of bleach, with a tidy bed and pristine white furniture and dim overhead lighting. I peered at the few objects and the many pictures clustered on a low table. Going to them, she pointed at each one, lisping under her breath, and I imagined she was speaking of her husband and son and daughter and cousins and nephews, of her sister and brothers and teachers and priest and niece. I was guessing; I could barely hear her. I had the impression of broken English, a thick accent I had no way of placing. As she continued to point at each picture, I looked at her, struck at once by the gentleness of her expression. My anxieties quieted. She had a soft-featured face with kind eyes, and her smile was not like the usual smiles of grown-ups — neither social nor calculated. Her warmth, her appreciation for all these people who had

made her world what it was, some of them already old in the photos and no doubt dead, surprised me. I didn't in that moment understand what I was feeling, but now I would say it was a kind of awe at a girlhood spent so far from where we then found ourselves, and also at this visual evidence of connection across the generations, of unbreakable human affection.

At last, she sat on her bed, tired. She was still smiling, but I understood that what she had meant to accomplish had taken place, and I was now to leave. Not knowing what to say, I said nothing, only nodded and smiled back. I wandered out into the bright halls to look for my father, who would drive us home.

Later, when I asked my mother about the woman, she gave me a curious look. "What are you talking about?"

I described to her the black-haired woman with the small, chapped hands, the kindliness of her lined face, the room just off reception cluttered with pictures.

"You must have met Mr. Gold," she said with exasperation. "Those pictures drive us crazy. They're always on the floor, we're constantly picking them up."

I told her she must be mistaken; it was a woman. Didn't she know every resident on her ward? It was my mother's job to know each and every one of them.

She began to smile that dismissive smile that makes children feel so helpless, as if their hold on reality is tenuous. "It was Mr. Gold you met. Not a woman," she said. "There is no woman."

6

WHAT ARE WE TO MAKE of those ghost stories with no ghosts in them? The places where ghosts should exist, but don't?

In March of 1868, a man by the name of William Robinson was shot dead in his home on Saltspring Island, British Columbia. It was the second of three such murders in a two-year period. All of the victims were Black men.

Saltspring is the largest of the Gulf Islands in the Salish Sea, separating the mainland from Vancouver Island, where I have lived for twenty-five years. For decades Saltspring has been mythologized as a countercultural refuge, a community of artists and hippies, of aged draft dodgers and craftsmen and eco-warriors. This is both true and a distortion. In earlier centuries, Saltspring was home to the Coast Salish Peoples before the arrival of immigrants in the mid-nineteenth century, peoples as various as the Portuguese, Hawaiian, Scottish, Irish, English, and African Americans. In 1858, on the assurance of the colonial governor, Sir James Douglas — himself a mixed-race man of Guyanese descent — Black people made the trek north from California in hopes of finding a more equitable society after the passage of harsh anti-Black laws in that state. They arrived to find a different west, one that both allowed them to indulge in new freedoms and reinforced their lack of agency. They were vulnerable everywhere.

William Robinson belonged to this first wave of settlement. The details of his killing were written up in the local papers of the era and, as with every narrative, took on different dimensions in the telling. Robinson lived alone in a windowless cabin of barked and denuded logs by the steamboat landing. He had not been seen in the village for some days. A man who acted as his occasional farmhand had picked up some ordered goods and tried several times to drop them by Robinson's house. His knocks went unanswered. There being no windows in the cabin, he pried out the packing from between two logs and peered in. The sight startled him: a stern black boot on the floor, unmoving. He poked the boot with a stick and felt the weight of a foot.

It took a full two days for the resident constable to make his way to the homestead. As the murderer had stolen, along with other items, the keys to the home, the constable forced a log from beside the door jamb to turn the lock from inside. The house was tidy and smelled of old smoke. There was a small bed along the far wall, a plank used as a table. On that table lay a cup, a saucer, and a plate upon which a meal sat untouched, a dinner of bread and salmon and mashed potatoes. And at the foot of the table, knocked with force to the floor but still neatly seated in his chair, was the body of William Robinson, dead one week.

He gripped in his left hand a case knife, and from his nostrils had leaked a thin stream of blood, dried in soft threads across his face. He lay on his back, his waistcoat

flayed apart, the fabric singed. Two bullets had passed through his chest.

THOUGH SOME HAVE WRITTEN that Black settlers like Robinson found Saltspring to be more racially benevolent than the places they had left, the murders suggest a different narrative. In a series of online archives, a historian noted the lack of prejudice on the island, stating absurdly that most settlers were too busy establishing their homesteads to worry about racial difference, while also relating in the next paragraph the story of a "Mrs. Lenniker," who told the local reverend that neither she nor her husband would "come to any meeting where the colored people associate with the white." Though I've no doubt that Saltspring did offer certain consolations, it was clearly no utopia.

On June 3, 1869, the trial of "Tom the Indian" for the killing of William Robinson came to an end. The accused was found guilty and sentenced to hang.

"Tom the Indian's" true name was Tshuanahusset, and his trial was less complicated than it should have been. He had pleaded not guilty. In the end, his conviction came to rest heavily on the testimony of a single witness, a man called Schystatis. The newspapers made much of the witness's Indigeneity, as if this shared ethnicity gave some special legitimacy to his testimony. Little weight was granted to the fact that when the constable went to arrest Tshuanahusset, he did not

know where the accused lived and so, with a local man, simply searched the cabins of other Indigenous people until he was directed to the correct one. He arrived to find Tshuanahusset not home, and so began and ended the search in the man's absence. An auger taken from Tshuanahusset's house to place into evidence went missing on the short journey to the mainland. The trial also glossed over the details of his infirmity — Tshuanahusset was said to be so ill he could scarcely walk without a cane. But the narrative had already taken on its own velocity, and it flowed relentlessly forward.

ROBINSON WAS NOT THE only Black man victimized during those years, and Tshuanahusset was not the only Indigenous man convicted for such a murder. On August 1, 1867, the body of a man was found half-buried beneath wood flooring and six inches of dirt in a stone cutter's house on the island's north end. He was so badly decomposed that the *British Colonist* newspaper first reported he was a white man. His identity remained unknown, but he was eventually assumed to have been a Black deserter from an American ship. In a move to cover up the murder, the killer had attempted to burn his house to the ground but had only partially succeeded. The report from the magistrate's office, dated thirteen days after the body's discovery, makes note that "two strange Negroes were observed lurking about the island." And yet even this document concludes that a white resident

of the island, Thomas Griffiths, was seen by people from several different communities in the immediate vicinity of the house with a shotgun, and that shortly after he left the area, the home's roof was discovered on fire. Griffiths was described at the coroner's inquest as "a very respectable man." When he was eventually questioned, he is said to have answered that he "did not suppose there would be any trouble about it," meaning, I believe, his possible role in the murder, and he was right. He was never charged. Several months later, on December 28, 1867, the *British Colonist* revealed that the remains of the unknown man had never been interred, and "that the bones lie there bleaching on the ground."

Eight months after Robinson's murder, on December 13, 1868, Giles Curtis had his throat cut and was fatally shot in the head in his own home. Some believed this had to have been committed by the same person who'd killed Robinson, as the circumstances seemed hauntingly familiar. Others felt there had to be several murderers. As had happened with Robinson's killing, several Indigenous suspects were rounded up and one eventually charged, a man referred to only as "Jim." In his report, Magistrate Morley speaks of the "bad character" of the Penelakut. Local law enforcement appeared to seek few answers outside the Indigenous community, and it is clear that everything was concluded with extraordinary swiftness.

• • •

WHY DO WE REMEMBER some dead and forget others? One cannot, of course, force someone's memory into myth. But in confronting the stories of these men — both those murdered and those hanged for the murders — one cannot help but ask what makes a person a worthy candidate for ghost-hood. The killings must have felt both random and targeted, and the punishments random and targeted, too. One imagines an atmosphere of dread and suspicion in those years. The deaths were vicious and the convictions betrayals of justice that, because of the death sentence, could not be undone. And yet in the annals of hauntings, one hears little about them. A recent search of Saltspring ghost stories yields mention of a man drowned in Weston Lake in the late 1960s, and the murdered proprietor of the Harbour House Hotel, whose ghost refuses to cede ownership. But I could find nothing about Robinson or Curtis, about "Jim" or about Tshuanahusset, the man eventually hanged for Robinson's murder. These are not the stories we remember, and these are not the ghosts we want.

Though the murders were personal, specific to the individual, they were also in some measure rooted in the emerging culture. The racial division Robinson had attempted to escape was clearly playing out in his new nation, too — with different actors, for different reasons, but going on all the same. We tend to brush aside such stories in favour of more straightforward tales of "settlement" — romanticized visions of pioneer life, in which the reality of hardship is offset by the satisfying rewards

of honest work and ownership. And so we continue to dismiss Robinson and others like him from our histories, by refusing to see their ghosts.

7

IN MY TWENTIES, I would leave the squalor of my half-empty apartment to attend parties in the squalor of my friend Julie's much fuller one. Julie was a fellow poet in the program at the university, but she was also one of those artists whose talent is so chaotic not a single medium can contain them. She wrote and she painted and she sewed notebooks; she designed clothes and built wooden frames and on Saturday nights sang in a friend's acoustic band. She was beautiful, too, with a heart-shaped face and fine white teeth and skin like a cup of clear tea. But she lived in a sinister building, filled with a wrong feeling. Some among our friends would not go there.

I remember climbing the flaking staircase of the five-storey house, a once grand and illustrious single-family home that decades before had been renovated into a warren of dark apartments. Each unit was sectioned off strangely, so that some of the suites had glorious old claw-footed tubs while others lacked any bathroom amenities save a toilet and sink. She'd had the good sense to rent one with a tub. Any friend brave enough could come up for a good soak.

Dusk was already falling, and when her buzzer was

finally answered, I could hear the party in the background. I entered the dark foyer with its cracked stained glass and began to mount the main staircase, which in its day would have been a thing of beauty but which groaned and buckled under my step. The narrow hallway was filled with the sound of human voices that must have been emanating from the party but that seemed in the moment without a source, as if coming from nowhere, or everywhere. The air was hot, the apartment doors I passed marked with shoe prints and dents. I shivered, remembering a story Julie had told me about returning home one morning from a boyfriend's house to find a journalist interviewing her neighbours, who were clustered out on the lawn.

It turned out that the neighbour across the hall had been stabbed. Julie was shocked. She had known the woman only by sight. Was she okay?

The woman had survived. But she would pass away the next day, in hospital. Julie would later tell us, stifling her horror, that the woman had died not from the stab wound itself, but from the bacteria on the knife.

This, sadly, was the kind of story that informed the place.

I climbed and climbed; her building was so dizzyingly vertical that more than once on my visits I'd found myself on the wrong floor. That evening I climbed by instinct towards the source of the music and voices. But the noise was emanating from who knows where, and I suppose I was not really paying close attention. I found

myself on the topmost floor, on a tiny landing, a floor it was clear no tenant could live on and which must serve as a storage place. I was about to go back down when from the side of my eye I caught a flash of motion, and I turned.

There, in the glass pane of a sealed emergency door, stood a man. His face was large and wide-nosed; his skin looked waxy, grey as an old bar of soap. He stood unsmiling, in absolute stillness. His body emanated a great silent intensity as he stood framed in the glass like a portrait.

I screamed, and felt instantly embarrassed for screaming. And then I screamed again. I turned and ran stumbling down the flights until I could hear the party very clearly, its thumping music and yelling male voices, and I grabbed the door and flung myself inside.

I must have looked wild with terror; as soon as I entered, the crowds seemed to part. Breathless, I began to explain what I'd just seen, though as the words flowed I felt more and more ridiculous; even so, people rushed past me and propelled themselves up the stairs. Everyone felt it must be the woman who'd died in the stabbing, despite my description. They returned skeptical, amused, uncertain. None had witnessed anything remotely ghost-like, beyond the reflected images of their own faces in the glass. Our friend Kyle poured me a beer stein full of Glenlivet, told me to sit down, I needed it.

Julie came up and touched my hand. She asked if I could hang back and help clean up after the party, which

I took to mean she wanted to talk privately. I nodded, and she was pulled away to drink with another friend.

If I remember this evening so clearly, it is because of all that happened afterwards. The following summer, in a town far from our city, Julie would pass away, suddenly, at the age of twenty. The building itself would over the years be set on fire and then saved and then set on fire again until it was condemned and fenced in and left to rot in the rain.

But on that night, when the last guest had left the party, Julie handed me a cracked coffee mug of red wine and began to ask in detail about what I'd seen. I described the man's heavyset face, his muteness, his almost violently quiet eyes. She nodded as I talked.

Then she rose and selected from a tower of dog-eared books a bright orange photo album. She opened it to show me pictures she'd been taking, or trying to take — they were all of a piece, I was astonished to see, each a mostly black or mostly white or mostly grey smudged print: wisps of movement across darkness, or empty doorways, or hallways shadowed or black. These were, she said, attempts to capture images of all the things she could not explain, of weird feelings that had come over her in the most common of places — in bathrooms and foyers and swimming pool change rooms. She'd been influenced by the spirit photography of the mid-nineteenth century, when the imprint of ghosts was sometimes seen in the background of portraits. Many people at the time had been convinced of the truth of

these portraits, though the images had resulted from moving objects or refracted light, or by the new use of double exposures. Even now some are inclined to see in them real ghosts. Julie herself was a skeptic looking to believe, and she charted her own path. Nothing definitive had turned up in her images so far, but she was not done trying. There were so many possibilities for connection: the dead formed a vast citizenship. There were the recent dead and those who for thousands of years had lived off these soils before the timber house we now found ourselves in was built.

And what would it mean, I asked, if she managed to capture an image of the man at the top of the stairs?

She took a drink from her mug, paused. "He'd be seen," she said, as if that was enough.

CHAPTER THREE

AMERICA AND THE ART OF EMPATHY

1

IT WAS THE AUTUMN OF 1986. I lay alongside my friend in her rec room, the two of us huddled under blankets so old their threads parted at a touch and gave off smells of rust and strong rose soap. Outside, an October storm was raging: the wind threw sprays of ice against the high windows, the panes already darkened with sleet. I remember the brick fireplace groaning ominously, as if a great piece of furniture were being forced down its shaft. Looking back, it was a typical fall evening in Calgary, with bouts of howling, ferocious weather. But in my friend's home, the storm took on a mythic dimension, as if all that dark pressure expressed what I could not bear to utter: that my nerves were frayed, that I was elated. Our friendship was new, just finding its feet, and I'd been

gleeful and terrified to finally be invited for a sleepover. We would do the usual eight-year-old rituals, rites that, observing my own daughter decades later, seem sacrosanct: paint our nails, comb each other's hair, gossip, and watch movies. Our night alone, secreted away from our other friendships. A deeper beginning.

Except that things turned out quite differently. I have no idea why we chose the movie we did — perhaps we got tired of endlessly switching the television's twelve channels; perhaps the old-fashioned clothes caught our attention, Claudette Colbert's dark, slim suit. Perhaps it was that neither of us had ever actually seen a black-and-white movie. Whatever the case, as we watched the drama play out, I felt, suddenly, unaccountably, cold.

The movie was *Imitation of Life*, the 1934 version, and even from my eight-year-old perspective I sensed the most crucial scene was missing. It took place wholly offscreen, but I felt it sharply, jarringly, like a missing page in a book. In this lost scene, Jessie, a young white girl, calls her best friend and childhood roommate, Peola, "Black."

Instead, the film rushes to show the aftermath, the reactions of grief, anguish, and fury. That little Jessie is simply stating a fact is apparently an irrelevance. She has given shape to a truth long unuttered, conjuring with that single word links to an intolerable past, a past that would never have allowed for the premise of equality and sisterhood on which their friendship is built. For though Peola is the daughter of the Black maid, the girls have

been raised as siblings. Peola is also so light-skinned that outsiders' assumptions of actual shared blood between the girls is not ridiculous. Peola, in fact, has come to see her true self as white — an identity reflected by her physicality — and she tries several times to pass herself off as such. But the passing is just that — fleeting, uneasy to claim beyond the moment, so that when her friend utters the word "Black," the careful identity she has constructed for herself comes crumbling spectacularly down.

"I'm not Black!" Peola cries, turning immediately on her mother. "'You. It's 'cause you're Black. *You* made me Black.'"

My friend glanced at me, her green eyes casually assessing, taking me in. A new awareness washed over me, a sudden sensitivity to our physical differences, her hair red and fine and tied calmly back with a gold ribbon; mine black and springy, tucked behind ears dark and small as beetles' shells. My face filled with heat: I sensed I was to account for something I could scarcely understand. Whatever essential knowledge I was meant to have brought to the viewing I simply didn't have. Something remained opaque, something my friend had seen with the clarity of water.

We all construct our own identities. But we all understand, sooner or later, the limits of doing so — that there are ways in which our practical, economic, and physical realities are fixed. There is the makeup or the clothes, the false modesty or the self-aggrandizement; but there are also the inherited eyes, the stubborn shyness, the cycle of

poverty, whatever it is that refuses to give way. *Imitation of Life* seemed to offer a grimmer lesson. Not only could others despise you for the fact of your difference, you could also hate yourself. Never had I seen the idea so starkly distilled. I understood then that a parent could be a profound source of shame beyond the usual embarrassments, a shame at once perverse and innate. One could, and possibly even should, feel a deep humiliation about one's origins, and — more shockingly — one could blame one's parents for being brought into the world in so despised a form. Their genes were what had made you this way, and because of this they should be prepared — and even expect — to suffer your loathing.

I was shaken by these ideas, laid so bare. It had never occurred to me that the uneasiness others might feel about my race should be something I myself carried. *Imitation of Life* clarified how the pressure of that outer gaze could dismantle one's own way of seeing.

2

WHEN WE TALK ABOUT racial passing, it is nearly always the same story: Blackness becoming whiteness. It is a narrative haunted by the ghosts of slavery, by the Caribbean Apprenticeship system and the American Great Migration, by colonialism and apartheid. In short, by any and all eras in which people have sought to classify and restrict power based on race, which includes our own era. The figures who come to mind are those like

Salomé Müller and Jane Morrison, two blonde, blue-eyed runaway slaves who in their respective eras fought in the Louisiana courts to be freed. In both cases, the women used their very pale skin as argument and proof that they should not be re-enslaved. We also think of literary figures like George Herriman and Anatole Broyard, Louisiana Creoles who, in the case of the former, claimed to be Greek, and in the latter's case, became white by omission, so that his daughter only learned of her African heritage after her father had passed.

One of the most tragic stories is that of Elsie Roxborough, the socialite and state senator's daughter who wrote a gossip column for the *Detroit Guardian*. She was as well known for her romantic life: she briefly dated the boxer Joe Louis and the poet Langston Hughes; the playwright Arthur Miller admired her beauty. After failing at an acting career in California, she eventually settled in New York. There, she'd adopt the name Mona Manet and begin to live as a white woman. Her decision was said to have been prompted by the racism she encountered when trying to secure acting roles or place pieces for publication, but no doubt other ghosts haunted her. Her father, apparently unhappy with her choices, disowned her. In 1948, she was found dead in her Manhattan apartment: she had overdosed on sleeping pills. Only her sister came to claim the body and bury her; she too was very light-skinned, and so would not betray her sister's secret. On the death certificate, Roxborough's race was listed as white.

The scholar Gayle Wald defines passing as an act rooted in the desire to have some control over how others view you racially, "rather than be subject to the definitions of white supremacy." Similarly, Randall Kennedy describes it as "a deception that enables a person to adopt certain roles or identities from which he would be barred by prevailing social standards in the absence of his misleading conduct." Both suggest that passing involves the taking on of a false identity to ease one's movement through society.

While passing is far from a purely American phenomenon, its history in America is instructive. America codified racial passing with the 1896 U.S. Supreme Court case *Plessy v. Ferguson.* Homer Plessy was an "octoroon," meaning a person of one-eighth Black ancestry. As a light-skinned free man, he deliberately violated Louisiana's Separate Car Act by refusing to sit in the train car reserved for Blacks. The Supreme Court found in the end that a law distinguishing Blacks from whites was not unconstitutional. In that moment, the "separate but equal" doctrine became enshrined in the American consciousness.

It also gave birth to the so-called One Drop Rule, which classified anyone who had even a single theoretical "drop" of Black blood as a Black person. If someone appeared white but was designated Black because a grandparent five generations earlier had been Black, no distinctions were made for these subtleties of inheritance. I think, then, of my own children, who have

Ghanaian ancestry, but who are also in some measure French, Scottish, Welsh, and German. Within such a system, their ties to these less outwardly visible histories are obliterated. To question the One Drop Rule, then, is to insist on race's changeability.

Racial passing was, therefore, about freedom and privilege — about being able to move through the world unremarked upon. What freedoms might be sacrificed in return, what other certainties and human comforts, was a separate question.

3

IN THE AFTERMATH OF Barack Obama's election, I was often asked by interviewers if we'd arrived in a post-racial age. I began to wonder why people kept asking. Did they really believe the presence of a single — albeit formidable — bi-racial man in the White House could destroy all traces of a noxious past? As I shuffled my way from interview to interview, growing more tired and less certain, it dawned on me that the question didn't want to be answered. The questioners were just expressing a deep, unsatisfied longing.

The "post-racial world" is brought up ever more frequently these days. The Trump era and its lingering aftermath have made it violently clear how far we are from that still. And yet, if years of protest against police violence have suggested anything, it is that the yearning for a future beyond race is elemental — and so all

the more powerful. Protesters of every race took to the streets, risking tear gas, beatings, arrest. Despite everything, the whole process felt, on the balance, hopeful.

But is it?

A world post-race is a world in which everyone feels they can live as their freest self. If, historically, Black people racially passed as a way to gain privileges denied by written law and social codes, what are we to make of people who pass the other way, from whiteness to Blackness? (Colloquially, this is called "Blackfishing," which draws from the slang "catfishing," meaning to assume a false online identity with the goal of luring someone into a relationship.) What would compel someone to take themself from a place of societal advantage to one of lesser cultural and political capital? Why willingly relinquish one's privileges? Is this, like the worldwide protests, where self-expression meets solidarity? The natural evolution of an extreme altruism?

These questions came to interest me in the wake of discussions with Black artists about white ally-ship. Some of the artists felt dismayed by what they had seen at the protests following George Floyd's murder. Some had observed purely performative gestures of solidarity by white protesters, rather than an actual desire to understand and inhabit the issues in a visceral way, issues of literal life and death to Black people. The image, for instance, of the white protester urging four Black protesters to kneel on his head to re-enact Floyd's death was beyond the pale. More nuanced, but still questionable,

was a scene described by Stacey Patton in the *Washington Post*, in which white protesters staged a mass die-in where they lay on yoga mats with chalk outlines around their bodies, chanting "I can't breathe" for the length of time the police officer had knelt on Floyd's neck. One can envision how startling such a scene would have been: the sea of bodies across the dark pavement, voices sharp and rhythmic in the still air. But it does leave one wondering what is gained. Are such scenes, as Patton put it, a "cosplaying of the dead . . . akin to white people imitating lynchings in the early 20th century by pretending to hang from trees in a show of solidarity"?

At issue, then, is the idea of empathy as performance, and about just how far one might take things.

In 1948, Ray Sprigle, a sixty-one-year-old white journalist for the *Pittsburgh Post-Gazette*, spent four weeks travelling through the American South as a Black man named James Crawford. A decade later, John Howard Griffin would spend three months doing the same, eventually coming to publish his acclaimed account, *Black Like Me*, in 1961. What knowledge, I wondered, did each man expect to expose when he was setting out, and were the truths they uncovered lasting?

Ray Sprigle had previously won a Pulitzer Prize in 1938 for his reporting on Hugo Black, a new appointee to the U.S. Supreme Court whom Sprigle discovered had been a member of the Ku Klux Klan. Sprigle was a muckraker and a colourful character; he was often to be seen champing grimly on a corncob pipe, his face shadowed by

his large Stetson hat. A fellow journalist described him as a "full-blooded Pennsylvania Dutchman" who was a "staunch conservative Republican who hated FDR and the New Deal." But as Sprigle saw it, his job was not to preach from inside his own beliefs but to get beyond politics to the heart of injustice. He apparently saw himself not as a moralist or a Civil Rights crusader but above all as a shrewd investigator. Before "James Crawford" became a Black man, he was a generally useful pseudonym that allowed Sprigle to take on any guise he needed. "James Crawford" entered several state mental hospitals so that Sprigle might write about their appalling conditions; "James Crawford" also went into the coal mines, allowing Sprigle to expose the illegal gambling rings there. Three years before his racial transformation, he went undercover to shed light on Pittsburgh's wartime black markets.

John Howard Griffin took a quieter approach. A heavyset Texan with dark eyes peering calmly from his softened face and a gentle cleft in his chin, he had been born in Dallas after the Great War to a pianist mother who passed down her love of music. As a teenager, he travelled on a music scholarship to France, where he also took courses in literature before going on to study at a medical school. When the Second World War broke out and the Germans began advancing across Europe, eventually invading France, he volunteered for the Red Cross, and under this guise secretly gave medical treatment to members of the French Resistance. Along with

a Jewish friend, he found homes for Jewish families to hide in. When these families were nearly discovered, Griffin and his friend swiftly dressed the children in the straightjackets of the mentally ill and smuggled them into Red Cross ambulances. The children were driven to the coast to make the long journey across the water to safety in England. Griffin had saved twenty-four lives; he was nineteen years old.

He returned to America, joining the Army Air Corps, which stationed him in the South Pacific. He spent two years in the Solomon Islands and was decorated for his service. It was after this time that a period of physical hardship began. He suffered an attack of spinal malaria that left him unable to move his legs, but recovered, miraculously. The lingering effects of a shrapnel wound led to temporary blindness. During these years he converted to Catholicism and began to think about the other ways he might have lived blindly, how his privileges as a white, able-bodied man had encoded in him certain prejudices. He returned to his childhood state of Texas, to teach piano. He married and would go on to have four children. In 1957, he spontaneously regained his sight, another miracle in a life that seemed rife with them.

SPRIGLE'S AND GRIFFIN'S ROUTES to Blackness were similarly comical. Griffin used skin-darkening pills and tanning, shaving his head to disguise his hair texture.

Sprigle — after many misadventures with Argyrol, iodine, pyrogallic acid, and the juice of walnut hulls — simply tanned his skin and changed his hat. If the change of a hat and a tan seem unlikely to amount to a radical racial transformation, allow me to suggest that the boundaries of race are fluid. As Sprigle himself wrote, "most of my concern over acquiring a dark skin was so much nonsense. Everywhere I went in the South I encountered scores of Negroes as white as I ever was back home in Pittsburgh." He also recognized the role dress plays in marking us culturally. As a white man, Sprigle was known to wear an expensive black suit and tie, and to carry a silver-ringed cane. When he "became" Black, he had his "glasses reset in enormous black rims, and acquired a cap that drooped like a tam-o-shanter." He also put on a dull brown suit. These were as much signifiers of his station as his darkened skin.

Sprigle would travel for four weeks and four thousand miles, chronicling his Black experience in the hopes, some cynical modern commentators have suggested, of winning another Pulitzer Prize. He does himself acknowledge that at the outset he wasn't bent on any crusade, but only looking out for the best newspaper story. This breezy attitude comes to seem like prestidigitation, however, when one considers his political awareness as a journalist, and the tumultuousness of his era. The Second World War had only just ended, and with that came the horrific revelations of Europe's devastating biological racism. The United States was

emerging as a new world power, making the need to address its own racial shortcomings increasingly more urgent. Jackie Robinson had begun shattering barriers as the first African American Major League Baseball player. Senator Strom Thurmond and other Southerners walked out of the Democratic National Convention in protest of their party's new commitment to Civil Rights.

Sprigle realized that in order for his experiment to work, he needed to come across as legitimately Black not only to white people but to the Black community especially. The executive director of the National Association for the Advancement of Colored People (NAACP), Walter White, offered advice and support, even urging a colleague to travel alongside Sprigle. White himself was a veteran of experiments in racial passing. As a blue-eyed, light-skinned Black man, he'd spent a long career passing as a white man to investigate lynchings on behalf of the NAACP and progressive newspapers. White's blessing bestowed a kind of permission, and granted Sprigle an initiation of sorts.

Blackness, Sprigle soon learned, was defined by a set of rules and limitations: one must, for instance, never fail to say "sir" when speaking to a white man; never speak disrespectfully or familiarly to a white woman; never talk back to a train or bus conductor — this latter being a rule that Homer Plessy came to intimately understand. But he also notes that these rules and limitations were sometimes wildly arbitrary. In his series of articles about his experiment, "I Was a Negro in the South for 30 Days,"

he describes the experience of sitting in the waiting room of a Black dentist, a kindly, courteous man with "very, very black skin" who was a graduate of a prestigious Northern university. The waiting room was filled with "white farmers in from the country with their wives and youngsters to get their teeth 'fixed up.' Other, better-dressed whites, men and women, plainly city dwellers. And a handful of Negro mothers with their children." He notes with irony the lack of segregation among the patients, into whose tender mouths the dentist must place his soft, dark fingers. And yet, were the same man who eased their pain to try to sit beside them on a bus or a streetcar, he would no doubt be arrested, even killed.

JOHN HOWARD GRIFFIN ALSO struggled with the shocks of racism. In *Black Like Me*, he describes an instance of being cruelly confronted on a bus. And here it is worth noting the differences between the two men's narratives. Sprigle, interestingly, sometimes shies from looking beyond surfaces. In one instance, he even goes so far as to praise the Jim Crow train coaches as "surprisingly good," describing the reclining seats as "comfortable" and the washrooms as "really luxurious compared with those in some of the coaches I ride around back home." They were all-around "excellent accommodations." Griffin's narrative, by contrast, seems more steeped in indignities. Some of the scenes he endures are stomach-turning: being shooed away from white restaurants, as if his race

will taint the food; hearing from Blacks about the diffi-
culty of taking even brief trips away from home due
to the scarcity of "coloured" bathrooms and drinking
fountains, effectively confining them to their own neigh-
bourhoods; being constantly questioned by white men
about his sexual prowess and where they themselves
could find loose Black women. Most painful to Griffin is
what he refers to as the "hate stare." He writes: "Nothing
can describe the withering horror of this. You feel lost,
sick at heart before such unmasked hatred, not so much
because it threatens you as because it shows humans
in such an inhuman light. You see a kind of insanity,
something so obscene the very obscenity of it terrifies
you." It is this, beyond everything, that starts to get to
him: not racism's physical threats, but the way it distorts
the mind and dehumanizes everyone it touches, both the
hated and the one who hates.

ONE OF THE STRANGE but inevitable outcomes of these
experiments is that both Sprigle and Griffin were turned
into spokesmen for the Black experience. Often, when
the media sought out speakers on racial inequality, one
of these men, in their respective eras, would be asked.
In perhaps the most jarring example of this, Ray Sprigle
took part in a panel about racial segregation on *America's
Town Meeting of the Air.* Walter White of the NAACP was
also present. From the very first, Sprigle dominated the
conversation. Most remarkably, he spoke from deep

within his assumed identity, damning discrimination and oppression from the viewpoint of a Black man. Sprigle's Black perspective garnered a $400 speaking fee. For the same appearance, Walter White was paid $100.

John Howard Griffin would eventually tire of being the voice of conscience. He was hanged in effigy, and badly beaten by fellow Texans who didn't appreciate his message, eventually forcing him to move his family to Mexico for a time. He grew dismayed at the rise of Black militancy within the Civil Rights movement, which he felt made less and less space for white allies.

Reading both Griffin's and Sprigle's narratives alongside current-day critiques of them, a few things stand out. It seems too easy, from our more enlightened twenty-first-century perspective, to condemn their experiments as nothing more than outrageous forays into Blackface for the edification of white sensibilities. But we have to be more nuanced than that, I think, and consider both their intent and the eras in which their experiments played out. In 2021, the notion of "owning" our own stories is well established. Attempts are being made to grant underprivileged voices the space to express their own truths. We have come to an uneasy consensus that it is "wrong" to impersonate or speak on behalf of another's experience. But in 1948, in 1961, such notions didn't exist. And so, to convey the marginalized circumstances of Black communities to a white audience who may have had little to no engagement with Black people, the news was more powerful coming from the

centre. Sprigle and Griffin were ultimately white men writing for white people about a society in which whites held most, if not all, of the power. In an unintended self-referential turn, their experiments exposed how incomprehensible racism was to the privileged without a translation from those who were equally privileged. Without the ventriloquism of people like them, the lives of others were literally unimaginable. In conveying just how severe the Black experience could be, Sprigle and Griffin sought to hold whites accountable for perpetuating a system that caused needless hardship, and urged them to reach across racial lines to end it. Griffin especially made a point of stressing how whites, as the overclass and creators of a divided society, had a crucial responsibility to racially reconcile.

This is not to suggest that there isn't something inherently condescending in these experiments. But this condescension seems merely a natural acknowledgement of genuine power. It feels distinctly different from, for example, Thomas Jefferson's paternalistic view of African Americans. Rather, Griffin seems to be saying that since it is white people who establish and enforce the rules, rules that have terrible repercussions for Black lives, it is up to whites to begin the process of dismantling them. In the end, "I Was a Negro in the South for 30 Days" and *Black Like Me* did their work alongside Black activism and other forms of resistance to push Civil Rights to the forefront of the national consciousness.

Today's activist scenes of death on a yoga mat feel,

in some measure, akin to that type of high symbolism, though of course in a much altered form. They represent white people speaking to white people about power in a white-legislated society, though one quite changed from both Sprigle's and Griffin's eras. While not wholly ill-conceived — the empathy feels genuine — the end effect is uncomfortable nonetheless. It is meant to draw attention to the issue by creating a shock in the moment, and in that respect it is a triumph. But it is complicated by the very real progress that has been made, and by the fact that in 2021, every person can, in theory at least, speak for herself. Is this only a gesture in the direction of systemic change, a fleeting idealism that will not last? Where do we draw the lines between empathy, activism, and performance?

4

FOR RACHEL DOLEŽAL, THE CALLS to action, and the question of how to live a socially conscious life, brought about a serious reckoning. In 2015, Doležal, then the president of the Spokane chapter of the NAACP, was interviewed live on an ABC news program about threats she'd been receiving in the organization's mailbox. The conversation began rather routinely, but then came the startling question: "Are you African American?"

On the surface this seems a rather straightforward query — I would argue it is not, given America's long centuries of migration and miscegenation. But it was

Doležal's shocked face, her panicked response, that laid bare a possible deception. And very soon afterwards, it was revealed: Rachel Doležal — NAACP president, chair of the local police oversight commission, professor of Africana Studies at Eastern Washington University, and a founding organizer of Spokane's Black Lives Matter protests — had been born a white woman in Montana, to two white parents of German descent.

In an inversion of *Imitation of Life*, in which Peola's mother clumsily outs her daughter as Black, Doležal's estranged parents exposed their daughter on national television, criticizing what they saw as her racial fraud and her general dishonesty. Brandishing her birth certificate and photos of the blonde-haired, green-eyed girl she'd been, they spoke with disappointment about their errant child.

The fallout was illuminating. Doležal lost all of her posts, and with it her entire livelihood and means of supporting her family as a single mother. Beyond that, she lost her reputation, and was treated to a public lampooning still going on to this day. The jokes were relentless:

> I declare February 29th as #RachelDolezal Day because it's generally not a part of Black History Month, but every 4 years it pretends to be.

Comedian Seth Myers joked: "It was a beautiful weekend in New York. This is how nice the weather was: I went

outside without sunscreen for about an hour, and I was elected to run the Spokane NAACP."

The Urban Daily even ran an "Are You Blacker than a Rachel Dolezal?" quiz, which had questions such as:

What colour should potato salad be?
- ❐ Yellow
- ❐ White

and

Mary J. Blige doesn't need any hateration or holleration in this _____.
- a. dancery
- b. house
- c. club
- d. kitchen

When a journalist on the right-wing media site Mediaite recently referred to the African American CNN anchor Don Lemon as "openly Black," the Doležal memes came flooding back.

Doležal's story broke at a time of great social turmoil. The previous year had seen the deaths of Tamir Rice, Eric Garner, and Michael Brown, and in the months leading up to her "outing," Walter Scott was shot fatally in the back in South Carolina. In Canada, Andrew Loku and James Reginald Butters would be killed by police, just two in a spate of Canadian police shootings that year

involving victims of colour in the midst of mental health crises. The narratives were charged and painful, and during the collective public grieving, Doležal became a flashpoint. Some questioned whether she'd continue to identify as Black in the face of so much death. She was declared cancelled, no longer a funny story.

It is doubtful that Doležal ever found her own story very funny. In a documentary film made about her life and eventual public shaming, *The Rachel Divide*, Doležal comes across as emotionally frail, and wary. And as her later autobiography reveals, the true story — her version of the truth, in any case — is much more complicated.

Doležal was one of two children born to a deeply religious couple in Lincoln County, Montana, in 1977. By her own account, her upbringing was harsh, and coloured by her parents' religious zeal. Lawrence and Ruthanne Doležal were rigorously pro-life, and according to Doležal, they had the idea to adopt children to save them from being aborted. When the couple allegedly discovered how difficult it was to adopt white children, they settled on Black ones. They adopted three Black children and one bi-racial child, putting Doležal and her brother in the racial minority among their siblings. It would, Doležal suggests, begin to shake her certainties about the fixity of race.

She goes on to describe a household of alarming racial dysfunction. Lawrence and Ruthanne Doležal allegedly treated their children differently according to their skin tones. The four adopted children were often asked to

sing and perform for guests, something never expected of Rachel or her fair-haired brother. Her parents also referred to the bi-racial child as the smartest of the adopted children, seeing him as more innately gifted than the Black ones. Doležal's mother even went so far as to suggest that he might not be Black at all, but Jewish. The son with the darkest skin was allegedly slated for the worst treatment. Her parents referred to him as "blue Black." Writes Doležal in her memoir, "After bathing Zach one night, Ruthanne commented on the bathtub ring he'd left behind. 'This is why [white] people think Black people are dirty,' said Ruthanne. 'The residue from their skin looks like dirt.'"

But Lawrence and Ruthanne Doležal were widely praised in their religious community. In their annual newsletter to their Christian supporters, they asked for money to aid in the children's upkeep. According to Doležal, they profited handsomely, eventually going to live in an exclusive gated community in South Africa with a swimming pool and, ironically, Black servants.

Doležal, then, is what is termed "Black adjacent" — meaning that she has lived so deeply within or alongside a Black community that she can be said to be more than an ally. Her parents, she writes, were not at all interested in Black cultures and tried to raise their adopted children as if they were whites entitled to lesser rights. It was Doležal herself who began to school her siblings in Black histories. She taught them about Nat Turner, Malcolm X, Harriet Tubman, Martin Luther King Jr. As a teenager,

she was entrusted with their care, and she would bathe
and dress them, learn the complexities of Black hair care.
She was their defender, and she grew close and bonded
to them in every sense. "I knew that if I didn't serve as
a buffer for them against ignorance, misunderstanding,
isolation and hostility, no one else would," she writes. "In
the process, I became a kind of cultural translator, help-
ing them navigate the white world safely while trying
to keep them connected to the Black one."

Later, when Rachel goes on to adopt one of her Black
brothers away from her parents (with their permission),
things grow more complicated. Already the mother of a
bi-racial son, she senses the tension surrounding the new
addition, with him being the only truly dark-skinned
person in the family. It is then that Doležal's proximity
to Blackness, her adjacency, starts to cross the line. She
begins affecting Black hairstyles and darkening her skin.
As her biological son puts it in *The Rachel Divide*, "How
was she going to explain how [her adopted son] looked
when his mother was white?"

To hear Doležal speak is to understand that she sees
race as highly mutable, random, and fluid, which is
certainly the case. She writes, "Yes, my parents weren't
Black, but that's hardly the only way to define Blackness.
The culture you gravitate toward and the worldview you
adopt play equally large roles. As soon as I was able to
make my exodus from the white world in which I was
raised, I made a headlong dash toward the Black one,
and in the process I gained enough personal agency to

feel confident in defining myself that way." Years later, she will tell the hosts of the talk show *The Real*: "I was biologically born white, to white parents. But I identify as Black." In yet another interview, she says, "I've seen myself as Black since a very young child, and then that was kind of conditioned out of me. And then I started to be perceived as bi-racial by others in about 1998. And by about 2006, I, you know, started more identifying as Black openly."

Note in this last quote the use of the language of sexual orientation and gender identity — i.e., "conditioned out of me" as a young child, "identifying more openly." This conflation of race, sexual orientation, and gender identification would lie at the heart of a controversy that was to blow up in the wake of Doležal's public shaming.

5

IN THE MARCH 2017 EDITION of the feminist philosophy journal *Hypatia*, Toronto-born scholar Rebecca Tuvel published an article that made note of the fact that the Doležal scandal had taken place just ten days after Caitlyn Jenner's *Vanity Fair* cover was published. Tuvel found it striking that, while Jenner was celebrated for her bravery in finally living out her chosen gender freely, Doležal was despised and ridiculed for trying to live out her chosen race. If a person could be "transgendered," did it not then follow that a person could be "transracial"? Hers was a philosophical investigation, focusing on the

social constructs of these identities rather than on lived experience, and with an awareness "that race and sex are [not] equivalent, or historically constructed in exactly the same way." Countering the notion that Doležal was committing blackface, Tuvel argued that distinctions must be made between corrosive and benign racial identifications. Doležal was not merely physically presenting as Black, but was also steeped in the culture; she did not traffic in stereotype; her Blackness was lasting, not temporary. In the end, Tuvel concluded that the arguments used to accept transgendered identities could also be used to accept changing racial classifications so that they better aligned with people's inner racial identities. Wrote Tuvel, "Generally we treat people wrongly when we block them from assuming the personal identity they wish to assume."

The fallout from Tuvel's conclusions was swift. Some were furious that the social realities of marginalized people were being callously dismissed by a privileged, cis-gendered academic. They argued that Tuvel had naively ignored the troubled histories of marginalized groups. She was called racist and transphobic, having deadnamed Jenner and drawn what some considered offensive comparisons to religious conversion. Still others attacked her argument on the grounds that, left to self-identify, some people would commit racial fraud and occupy the few safe spaces carved out for people truly of colour. If it does anything, the controversy lays bare a disconnect between sexual/gender identities and

racial ones, and the thorniness of comparisons between them. But it also emphasizes how much our identities are also formed by outside factors, despite what we ourselves might claim.

<div align="center">6</div>

AT THE AGE OF NINETEEN, in Calgary, I applied for a summer job. I'd responded to an obscure advertisement seeking people with general office skills. The first interviews were conducted by phone. Afterwards, I was asked to come for a final, in-person meeting.

That morning I woke nervous and eager, dressing with care and taking great pains to braid my hair, which I wove into four long strips down my scalp. I could barely eat for my anxiety. On the long trip downtown, my brother, who'd kindly offered to drive, tried to make conversation. I was silent and irritable, turning over in my mind all the impressive things I would say. I arrived in the office's brown-carpeted lobby to discover myself among five other candidates. I was alarmed but hopeful, mulling over ways I might leverage my writing degree to advantage.

A man and a woman stepped from a hallway door, their expressions pleasant but filled with the briskness of people who inhabit their authority as comfortably as they inhabit their clothes. They surveyed the room with faint smiles, but when their eyes landed on me I saw their expressions falter. I was not the only one to

observe this — others instinctively felt their surprise
and turned with curiosity to watch as they crossed the
room over to me, taking care not to look at each other.
For a moment I thought I'd come to the wrong place;
from the moment they opened their mouths, it was clear
they thought so, too.

"Sorry, I don't know if this is where you're looking
for," said the man, his face soft and emotionless. "This
is for the office job."

I said that I was indeed there for the office job, and
mentioned the names they'd given me over the phone.

They fell momentarily silent. I understood. My voice
had not conveyed, as they felt it should have, who I truly
was.

They could not of course say this. They remarked,
instead, on how different I sounded in person.

"We're only interviewing for the one position," the
man said, not meeting my eye.

Only one position had been advertised in the first
place. I glanced around the room, at the five other people
seated in the lobby. They stared at me, some curious,
some nervous.

"I'm here for that position," I said.

"It was filled yesterday," said the woman, clumsily.

"We'll call you if something else comes up," said the
man. He walked me calmly but firmly to the entrance.
"We'll call you," he said again, his eyes finally meeting
mine, evincing nothing.

In the parking lot, my brother had just begun pulling

the car away. "Done already?" he said, leaning out the window. "So did you get it, then?"

As I stepped from the morning heat into my brother's car, what I felt was shame and confusion. I did not understand then that I'd been "constructed" in the minds of my interviewers, passing without my own knowledge or consent. The person I was and the person I seemed to be were not the same; in appearing as myself, I had revealed something about the people around me.

7

BACK IN 2015, WHEN Doležal's story was first exposed in the media, the idea of rampant Blackfishing seemed absurd. The life circumstances that led Doležal to be who she was — the Black-adjacent childhood, the education at a historically Black university — were all highly particular. The notion that this was not a somewhat isolated event, that white people might be inclined to change their race and occupy posts deliberately set aside for professionals of colour, seemed unlikely enough that one needn't guard against it.

But such instances happen more than one might think. Over the three-week period that I spent revising this piece, two more were exposed. CV Vitolo-Haddad, a scholar at the University of Wisconsin–Madison and co-president of the university's Teaching Assistants' Association, revealed they had fraudulently presented as Black. Vitolo-Haddad had been offered a tenure-track position at California State

University, Fresno; the offer has since been rescinded. They are in fact of Southern Italian heritage.

Vitolo-Haddad's admission came to light just two weeks after the appearance of a shocking post on the website Medium. In it, Jessica A. Krug, a historian and associate professor at George Washington University, admits to having "eschewed my lived experience as a white Jewish child in suburban Kansas City under various assumed identities within a Blackness that I had no right to claim." She said she had presented first as a Black woman of North African descent, before pivoting to African Americanness, and landing finally on a Caribbean identity by way of the Bronx. She anguished over having re-victimized communities with her lie. A member of the cultural elite whose scholarly focus had been slavery and colonialism, she lambasted herself as someone with special knowledge of cultural violence. She was especially critical of her past habit of viciously criticizing those who refused to acknowledge white privilege. "I claimed belonging with living people and ancestors to whom and for whom my being is always a threat at best and a death sentence at worst," she wrote. "I know right from wrong. I know history. I know power."

Krug rooted her passing in "mental health issues," but she also acknowledged that such issues could not completely explain away her behaviour. Indeed, her letter is so extraordinary — so anguished, so self-flagellating, so intense a surrendering — that it leaves one wondering what prompted the revelations.

As it happens, the impetus for her confession was less high-minded than her actual words would suggest. Rumours had been circulating for years. But it was the death of fellow George Washington University professor H. G. Carrillo, a prominent Afro-Cuban novelist who was discovered not to have been Afro-Cuban at all, but African American — itself a story — that finally brought things to light. Carrillo's surprising deception reminded colleagues about their doubts about Krug. They discovered their hunch was right, and they were in the midst of trying to agree on a way to hold her accountable when Krug apparently got wind of their intentions to expose her and posted the piece on Medium. ·

According to her colleagues, Krug's Afro-Latina identity was constructed on damaging tropes. When speaking to other women of colour, she would almost without fail use terms like "we" and "us." She affected a persona called "Jess La Bombalera," who spoke in what might be very loosely termed an Afro-Latina accent, and referred to herself as hailing from "the hood." In one video circulating on online, Krug vents her frustrations about a New York City Council hearing on gentrification in a kind of generalized caricature of African American urban-speak, throwing out phrases like "ain't nothin' change" and "power to all my Black and brown siblings for standing up," while excoriating white attendees for dominating the conversation. In her Afro-Latina persona, it is a strangely jarring rant; when one watches with the understanding that she is in fact white, the video gains an even greater

element of transgression, laying bare the same racist assumptions about Black female discourse for which Krug might have attacked others. It is ironic, even comical — and yet. Krug also built her persona on more serious and painful tropes, ones that have haunted race relations in the Americas for centuries. Among her various claims over the years was that she was of Algerian descent on her mother's side and of German on her father's, and that she was the product of her white father's rape of her Black mother. This would have raised the uncomfortable spectres of both slavery and colonialism, making others less likely to question her background.

<div style="text-align:center">8</div>

IT IS STRIKING THAT BOTH Doležal and Krug established their Black female identities on victimhood. The original focus of Doležal's fateful ABC interview was the threats she'd been receiving in the mail as the president of Spokane's chapter of the NAACP. After investigating these threats, however, both the local press and Spokane's police department concluded they were a hoax. The mail was not stamped and had therefore never gone through the postal system, so it had to have been placed in the mailbox by someone in possession of a key. Only two people had keys, Doležal being one of them. She had also made earlier claims that nooses had appeared around her home. In *The Rachel Divide*, NAACP member Kitara Johnson says, "We've had NAACP presidents long before

Rachel came here who were darker complected and they didn't receive that much hate mail. So how is this woman receiving this much hate mail?" (Note here the unconscious, casual reliance on colourism — prejudice based on skin tone — to determine and explain degrees of racist harassment.)

Part of why Doležal's case proved so frustrating to Johnson is that racism was endemic in Spokane, but in speaking out against it from a false identity, using false claims, Doležal had muddied the cause. "She was speaking truth," said Johnson, "but now, in Spokane, it's hard to push that message. And who's affected by this? All the people that the NAACP had been advocating for."

It's a salient point. To make false claims of victimhood is to dilute those claims for the legitimately victimized. This was especially sensitive in a city like Spokane, which did indeed harbour racist and far-right groups. It is in the city's best interest to delegitimize claims like the ones made by Doležal, because it implies others might be false, too, that all such narratives are at the very least open to question. This absolves the city of greater social accountability. (I should note that Doležal has always denied and continues to deny that she misled anyone; she maintains the threats were real.)

And this is the crux of why Doležal and Krug rankle — their Blackness is predicated on a sense of stolen grievance. Krug was known to berate her colleagues for not being radical enough in their approach to fighting racism, given all that women of colour had suffered

throughout the centuries. Of Doležal, NAACP member LaToya Brackett has said, "Every time she talks about anything that has to do with her Blackness, it's always about her struggles. And that seemed to be her way of reminding people that she's Black . . . She uses [her sons] . . . in order to have more struggle by proxy."

These last words — *struggle by proxy* — sum up a lot of our collective thinking when we look at protesting for the rights of other people. It is what Jean-Paul Sartre and his Existentialists were calling for when they asked us to view everything through the perspective of the disadvantaged. But to *become* the disadvantaged is a different beast entirely, and in the case of Doležal and Krug, the attempt to view injustices through the eyes of those who suffer the most seems to have inspired not clear-eyed empathy but a desire to suffer, too. If Black lives are always under threat, so goes the unconscious thinking, the construction of a Black identity must necessarily be rooted in ongoing victimhood.

Doležal and Krug buck against Gayle Wald's definition of racial passing as something taken on to avoid "being subject to the definitions of white supremacy." They wholly embrace identities that in fact make them direct targets for white supremacy. White supremacy itself helped to shape Krug's identity; it gave her a focus on which to exercise her formidable powers of dissent. This may be the case for Doležal as well, but she feels slightly different to my thinking, grounded in her family ties. Her journey feels closer to expressing Kennedy's

description of passing: an attempt to access a way of being that would be denied her in our world of sharp racial fault-lines.

9

THE TERM "TRANSRACIAL," HOWEVER flawed, seems an attempt to give us a new idea of racial passing, one shorn of self-interest. If we modernize the language around it, this might lead to modernizing our feelings around it, to changing our negative perceptions, to embracing it. Racial passing has been mired in secrecy and shame, in self-hatred. Transracialism, by contrast, is not about hiding one's true self; it is about exposing it, finally, about celebrating who one really is. To talk of transracialism instead of racial passing is, I think, to shear off its past of darkness, of illicitness. Racial passing is the story of hiding and loss; transracialism is the story of agency, of reclaiming the self. Racial passing is an old weapon wielded against an old set of values; transracialism suggests the world has grown beyond those values, allowing us to choose our race from a place of authenticity and joy. And yet, though much progress has been made, we are hardly *beyond* — the inequities, the race hatreds that made Elsie Roxborough, or even the fictional Peola, feel that life as a Black woman was unliveable, are with us still. And for some, so long as those inequities endure, the crossing of racial lines will always be fraught.

But is that fair? There are undoubtedly people who feel trapped in the wrong skin. What do you do when your very body doesn't feel like home? Should we all not have the chance to live out our inner selves freely? Our bodies are not just bodies; they are, for better or for worse, also metaphors. For me, in my personal mythology, my body is that of a Black woman but it is also a metaphorical and actual shield against all the worldly dangers that might hurt my children. This is the source of my fear of death — not just personal oblivion, but the peeling away of this layer of protection for them. Human beings do not simply exist — we mean. And when your personal meaning is contradicted by visual symbols you have no control over, the pain can be insufferable.

One argument against transracialism revolves around the idea of access. NAACP member Kitara Johnson has argued that "transracial[ism] is the epitome of white privilege." What I interpret by this is that transracialism lies solely in the hands of people who *can* convincingly change their racial identities. Because of the shadow of the One Drop Rule, a person from a privileged group who claims to be disadvantaged is more readily convincing than a person who comes from a disadvantaged group, looks it, and tries to claim otherwise. As Ray Sprigle wrote, "when a man says he's black, so far as they are concerned, he is." Such is not always the case when a man says he is white. The scholar Alisha Gaines points out, "If the police stopped a person of color, their

stubborn insistence, 'I identify as white,' would never be a viable alibi."

Since transracialism is not an option equally available to everyone, go the arguments, it becomes another privilege. On some level I understand the discomfort underlying that conclusion. I share it myself, though I'm not proud to admit it. When I turn transracialism over in my mind, I run up against my own biases and prejudices. While I cannot fathom, and find cruel, the idea of withholding equal rights to transgendered people, I can still be made uneasy by a figure like Doležal. The exact nature of her threat is difficult for me to unpack. But I believe it has something to do with the fact that I live out my race in a far more charged way than I do my gender. So much of my personal embattlement has been rooted in my Blackness, and I must feel, however illogically, that she encroaches upon and diminishes something of my experience. Part of my unease is no doubt grounded in the knowledge that at any point Doležal, grown tired of the vagaries and pain of racism, can simply walk away. This is a choice I cannot make. As I say, my conclusions are based on pure emotion, not reason, and I know they are terribly unfair to her. It's very possible that racial fluidity may be the next frontier.

Perhaps all our arguments around transracialism come down to a larger social disconnect between the individual freedoms we all cherish and the authenticity we now demand of everything. We want for everyone to be able to live out exactly the lives they wish, for

our children to grow up to be anything, for everyone to be free to experience their true selves. But we are also living now in a time when the concept of identity is fragile, and we put great stock in absolute authenticity. We ask that art transport us to places and into lives we could not have otherwise fathomed; but we also put fences around those imaginative acts, by demanding, for example, that only gay actors play gay roles, or that only Black writers write Black characters. In the 1959 film version of *Imitation of Life*, the racially passing daughter is played by Susan Kohner, who is not Black but a woman of Mexican-Hungarian descent. This is not something that would happen today. And the fact that it wouldn't aligns with my own biases: had the casting been more authentic, an actual Black woman would have gotten the role and more space made for Black actors in Hollywood, even in such dubious parts. But I also understand the new problems such thinking brings, when too brutally enforced. It becomes the opposite of freeing.

10

DOES THE GOOD THAT Doležal and Krug did change how we might view them? It is undeniable that both women made valuable contributions to the Black community. In her roles as president of the NAACP and head of the city's police oversight commission, Doležal forced complacent Spokane officials to confront the passive racism and racial violence that mark their city. Krug's 2018 book,

Fugitive Modernities, is an examination of colonialism in the seventeenth century, looking specifically at Kisama, a region in present-day Angola that fended off enslavement by the Portuguese. By all accounts the book is exemplary and ground-breaking, and it established Krug as a rising star in African American scholarship. Both women shed light on the unseen, and insisted hidden histories be reckoned with.

That level of advocacy on behalf of others is a rarity — and sorely needed. The work of equality is the labour not of the few but the many, including those who have benefited and continue to benefit the most from an unequal system. Change that must take place on a broad social scale must be just that — broadly social. Everyone has their part to play. But it is not for advocates to occupy spaces intended for the very people they are fighting for.

Having watched in real time as the stories of Doležal's and Krug's public shaming played out, I was left wondering: Why did they do this? They had risked so much. How difficult must it be to live every day with the pressures of possible discovery, knowing that at any moment the life you have elaborately built for yourself can be openly destroyed?

While historically crossing racial lines has, almost exclusively and for obvious reasons, been from a powerless group to a powerful one, today it seems the opposite can happen. And one of the most interesting things about Doležal's and Krug's passing is that they were criticized not for relinquishing their privileges but for

taking privileges away from marginalized groups. Seen in that light, theirs is a movement not away from power but again towards it — not power in the context of our larger social hierarchies, but power on the margins. For both women, this took the form of activism in the Black community and prestigious university posts reserved for people of colour. As white women, they seemed to live out their power more passively, as privilege. Only as Black women did they don their armour for war.

It seems, then, that part of their crossing the racial divide was to acquire something. Is it ever any different? Does anyone ever "pass" without such self-interest?

11

WELL, SOMETIMES, YES.

The story of Ada Copeland and Clarence King is undoubtedly the most complicated case of racial fluidity I've come across.

Ada Copeland was born a slave in Georgia just months before the state ceded from the Union. After the Civil War, she migrated north, like so many African Americans during Reconstruction, ending up in New York. She found work as a nursemaid in Manhattan, an option open to her because she was literate. I imagine the city felt both wondrous and terrible in its newness, the food strange and the streets chaotic, the winters vicious, with unbroken days of snow that lay grey and thick in the ice-choked gutters. How bizarre Northern life must

have seemed, how far from anything she might have imagined for herself back in Georgia. When, in 1888, she met James Todd, her fate must have seemed even more capricious.

Todd was a handsome, fair-skinned Black man from Baltimore who worked the railways as a Pullman porter, earning good wages. He had been born in the West Indies and immigrated to America in 1870, where as a naturalized citizen he became a travelling steelworker. Though he was nineteen years her senior, with work that would take him away for long periods, he still seemed to Copeland a good match. They married some months later, in a quiet civil ceremony at the home of Copeland's aunt. Only Copeland's family and friends attended, with everyone too polite to ask why no one from Todd's family was present. Who knows how Copeland herself processed the absence. But after the wedding, the couple settled down on Hudson Avenue in Brooklyn, in a predominantly Black neighbourhood, moving later to Flushing, Queens. Though Todd was frequently away, their marriage was by all accounts happy, the couple eventually expanding their family with five children.

In 1901, while Todd was travelling on business, Copeland received a letter from him instructing her to sell the house and move north, to Toronto. There had recently been race riots in New York, so the request struck Copeland as sensible enough. In May of that year, she crated up the detritus of her first years of freedom and took the family to Canada.

In December, Todd would again post an unexpected letter from the road. This one contained startling admissions.

Todd lay dying of tuberculosis in Arizona. This confused Copeland, as he'd been in seemingly fine health when last at home; somehow he'd managed to hide his condition. Even more shocking: he admitted his name was not James Todd, but Clarence King. And he was not African American, but a white man.

Born in 1842 in Newport, Rhode Island, King came from a wealthy and well-established family that traced its English lineage to the signatories of the Magna Carta. His father was a trader with Olyphant & Co., a merchant firm in the lucrative China trade renowned for its refusal to smuggle opium. His uncle was a diplomat and a key figure in American-Chinese relations. The Kings lived in affluence until 1857, when the deaths of both King's father and his uncle changed the family fortunes. Determined to regain their life of privilege, King's mother married a wealthy widowed factory owner in Brooklyn. This enabled King to continue his education in the country's most elite schools. He eventually earned a doctorate in chemistry from Yale and then went on to Harvard for post-doctoral work in glaciation.

He was admired as a great adventurer. In 1863, King headed west on horseback through the dry yellow hills of California, falling in with an emigrant wagon train on his way out to the mining fields. There he studied the Comstock Lode, and when the mine burned down, he set

off on foot across the high Sierras, gaining passage on a steamboat down the Sacramento River towards San Francisco. While aboard, he met the field director of the Geological Survey of California, and as a volunteer for that organization, he would go on to explore Southern California's deserts. He would eventually be called on to speak before Congress in Washington about mapping the southwest Cordillera and the fortieth parallel, the final stretch of land along the route of the Union Pacific Railroad. This put him at the forefront of a new wave of exploration. He led a delegation of scientists through the terrifying Donner Pass to collect mineral, plant, and animal samples, mapping the terrain and taking weather readings. When most of the exploratory party fell ill with malaria, King insisted on finishing the work, even after he himself was struck by lightning.

He was revered as much for his outstanding character as for his work. A member of every gentleman's club that mattered — the Knickerbocker, the Century, to name a couple — he socialized with presidents, congressmen, and the foremost thinkers of his day, including Henry James and James Weldon Johnson. He was known for his fine intellect and scalding wit, held in the highest regard by those closest to him. Henry Adams, the historian, grandson and great-grandson of two American presidents, said of King that "men worshiped not so much their friend, as the ideal American they all wanted to be." Abraham Lincoln's private secretary, John Hay, called King "the best and brightest man of his generation."

How strange to imagine him leaving that world for the smaller one on the other side of the city. To picture him leaving his rooms at the Century Club, slipping from his tailored jacket into a Pullman porter's coat, mounting the Manhattan streetcar to cross over into Queens and the family intimacies that awaited him. Which, I wonder, was the truer home to him? In which identity did he feel most at ease? Surely he must have paused, in his more thoughtful moments, to recognize how men like James Todd made possible the comfortable existence of men like Clarence King?

The answers are murky at best; King destroyed most of his letters, and insisted his wife destroy hers. His offences are many, but his story still has much to say about the ways we have constructed and continue to construct race.

HOW DID KING'S CIRCLE of friends remain in the dark? Moreover, how could Ada Copeland herself not have suspected?

Racial stratification had been so codified and internalized in America that the very discreteness of King's lives — the one socially gilded, the other impoverished — made it inevitable that they would never overlap. The racial segregation of New York's neighbourhoods cemented the near impossibility of his family or any friend from Queens catching sight of King navigating upper-class Manhattan in his fine wool suits. Similarly, the chances of Henry

Adams or Henry James passing through the borough where Copeland kept house were slim to none.

The question then becomes one of physical attributes. Clarence King was white-skinned, fair-haired, and blue-eyed. How was he able to convincingly blur racial lines? The answer to this lies, again, in the concept of the One Drop Rule. After the American Civil War, white Southerners were anxious to create a structure that would keep ex-slaves in a world apart. If, because of miscegenation, it was not always obvious who was Black, how could one ensure the separation of the races? In 1880, eight years before King met Copeland, the U.S. government released a census in which people were to declare themselves white, Black, mulatto (one-half Black), quadroon (one-quarter Black), or octoroon (one-eighth Black). Just ten years later, those classifications had narrowed, so that you were either white or Black. It remained this way for over a century — not until the year 2000 did the census again make allowances for mixed-race people.

It is clear that the verdict on what constitutes Blackness may be impossible to render. The racial categorizations invented to "solve" race and make it hard to move from one racial group to another actually ended up doing the opposite. Racial fluidity became more possible, because one could claim an ancestry that had nothing to do with one's skin colour. And so it was that Clarence King was able to claim he was Black.

We don't know how Copeland took her husband's confessions in the moment, though she did change her

name to Ada King. Was this an act of desperation, a way of trying to reinforce the legitimacy of her marriage so that she would not risk losing the little she possessed? Did she do it to avoid being branded a "fallen woman" whose sexual relations had taken place within a relationship unsanctioned by law? The scope of the betrayal is breathtaking, and one wonders if any meaningful forgiveness was possible, especially as she never had a chance to see him again before his death. King's treatment of Copeland was at best callous, at worst, cruel. Did she regard him in memory as a stranger, someone who'd placed himself beyond knowing? Or did a glimmer of familiarity remain, a path back to him? Perhaps, despite the new facts of his education and his famous friends and his tailored clothes, she could still see James Todd.

THERE IS OBVIOUSLY MUCH in King's experiences to mirror Doležal's or Krug's. But far more interesting, I think, is where their stories differ. Beyond the prop of the Pullman porter's coat, King apparently made no alteration to his essential self. He did not, like Doležal, darken his skin or change his hair. He did not, like Krug, affect a racialized accent. By all accounts, he no more over-performed his Blackness than he over-performed his whiteness.

The historian Martha A. Sandweiss has called King a "racial radical." As a wealthy white man, he accessed all the privileges he'd known from birth; as a Black man, he

willingly unburdened himself of those privileges, gain-
ing in return not social status but love. I do not say this
sentimentally, but it is interesting to note that, unlike
some of the other figures I've mentioned, he seems not
to have wanted anything beyond that love. A cynic could
argue that his passing was a way for him to escape the
stifling expectations and confines of white upper-class
life. But a decades-long marriage and five children is
quite a commitment, and there are easier ways to rebel.
We do not know what he felt in the years of his marriage:
whether he wondered at the madness of his actions,
gripped with nerves at being discovered. Was he filled
with jealousy in those long periods away from his wife,
or did he firmly shut the door in his mind, not spar-
ing much thought for those left behind? How badly did
he fear being shamed and exiled from his gilded world?
Which man did he inhabit more deeply?

What we do know is that he never abandoned
Copeland, always returning to her. His passing was not
born from, nor did it become about, what he could gain;
he didn't occupy spaces socially and politically intended
for others; he did not advocate in a way that drowned
out the voices of others.

King, in fact, made his strongest comments against
racism as a white man. When Henry Adams, a racist and
an anti-Semite, said offensive comments, King made a
point of trying to get him to reorient his gaze, to change
his narrative on race. He spoke not with paternalism, but
with a vision modern for its time, writing about a future

in which "the composite elements of American popula-
tions are melted down into one race alloy — when there
are no more Irish or Germans, Negroes and English, but
only Americans, belonging to one defined American race."
He wrote these words for a public that was disgusted and
scandalized by them, and he did not hold back.

However strangely King's racial fracturing played
itself out, his actions suggest he felt it was not for him
to decry injustice from inside his Black identity, but from
within the privileges of his white one. As a respected
scientist whose opinions were highly sought after, he
reached ears unused to such ideas. He relied not just on
his social status to shift perception, but also on his work
as a thinker and a writer, using lengthy arguments to
explore ideas of racial reconciliation, and drawing up
short his colleagues who expressed racist opinions. As
a white man, these were the roles available to him, and
where his advocacy was meant to end. While we cannot
know whether he felt he was living out an authentic
experience as a Black man, as a white man he was with-
out a doubt living out an authentic experience as an ally.
He called out prejudice in circles people like his wife
had no access to, and he did this without exploiting her
personal experiences or those of his children. His love,
in other words, gave not permission but illuminated a
separate path he could take, with its own slow work to
do in reshaping long-held beliefs, in urging people to
see differently.

CHAPTER FOUR

AFRICA AND THE ART OF THE FUTURE

1

BEFORE MY MOTHER'S DEATH, my parents forever retold the story of how they met. It was July 20, 1969, and they had both been asked to a casual party at the home of a mutual friend, to watch the moon landing on television. Like them, their friend was an African student of science and technology transplanted to the sea air and endless light of Palo Alto. He would serve Kenyan food and American beer to a small gathering of fellow new arrivals. It was, by my mother's account, an aspirational group: a pan-African mixer in which kids from regions thousands of miles away ate and drank and joked with each other, all differences ignored. When my mother finally arrived, rushing into the too-hot room, late and saying sorry, my father was instantly confused by her.

She was clearly, like him, Ghanaian, but she also clipped her *g*'s oddly, like an American. Her voice struck him as too old and imposing for such a person; at ninety pounds she was as slight as a child. She spoke softly but brusquely, apologizing, yes, but arguing that it couldn't be helped. Intrigued, he went to speak to her. He understood from the faint lines on her upper cheeks beneath her makeup that she was from a different tribe than his. But that wouldn't have mattered so much anymore back home, and here, on this bright, humid night in California, it was less than nothing. They shared much else, including a startling way of interrogating everything, especially other people's assumptions. More than that, they'd been drawn together to witness a thing beyond human categorization, a feat that belonged to no one race, no one tribe, but to all mankind.

That was their story. I grew up on it. We are all of us made up of stories, our identities intimately shaped by what we have witnessed and what has been passed down to us. As the writer Alberto Manguel has said, stories feed our consciousness by shaping our sense of reality through language, and this act can serve to transmit memory, to instruct us, to warn us. The story of my parents' meeting gave order and meaning to my childhood. It struck me as momentous that it should have taken place on so extraordinary a night, so that the encounter felt fated, preordained, making my existence in turn feel fated and preordained. It did not matter that I failed to fully understand all its symbols; it was a

history with a clear beginning, rooted in a precise hour on a day of worldwide celebrations. As an origin story, it was everything to me.

But the older I get, the more I sense a powerful shadow narrative running beneath their story. I've come to view it as a calibrated fiction, its emotional symmetry too perfect. There is the accident of it all (my father had to work early the next day and almost didn't go). There is the yearning and striving of their young lives at a point of promise, set against the backdrop of an improbable space program finally bearing out. The shock of possible love and the shiver-inducing sight of actual men walking the moon. Newness and hope all around. Two events, one great, one small, both occurring at once and wholly world-altering.

Their shadow story, the hidden one, is less precious, more tentative. It is a story of uncertainties, and at its core lie anxieties both national and personal. My parents had grown up in the British colony of Gold Coast and had come of age in a changed country, whose new name was taken from an ancient neighbouring kingdom: Ghana. It was the first of the sub-Saharan African nations to gain its Independence from colonial rule, in 1957. My father would have been seventeen years old; my mother, fifteen. Ages at which the world already takes on a sense of heightened unreality, with its sudden dramas, its everyday highs and agonies. It was a time of collective disorientation nationally, a time when the very idea of nationhood in all its excitement must have also dredged

up feelings of disharmony and alienation. How deep was the sense of dislocation — the feeling the old world was shuttered and the new one not quite open? What did it mean for these teenagers to suddenly live in a self-governing nation — to be citizens, finally, of a free state?

My mother never spoke of it openly. Instead, she used to tell a different story, one about her childhood, which seemed to stand in for a more direct answer. At ten years old or so, she and her friends would leave behind the heat and soft red soil of Accra, its street noise and open gutters, and make the long, slow trek to the seashore. They would arrive at the beach to the startling sight of English people sunning themselves on the white sand, their skin growing alarmingly pink even as they rubbed on more oil. Neither she nor her friends could understand why anyone would willingly bake their skin in the sun, and they sat in their Kente head wraps and ankle-length dresses, marvelling, though the sight was hardly new. The English had always been there, from long before her birth, so that they too were Africans of a kind, Africans who were not African, foreigners who were native.

England had so long exerted its power over the most basic facts of Gold Coast life that all human progress seemed to extend from that empire. What, then, was this post–Gold Coast society? What was their Ghana? English was still the language of power; people still wore "singlets" and had "tea" and drove cars in which the backs were equipped with "boots"; so thorough was

this colonial transference that I myself, a Canadian child, grew up using these words. What, in a post–Gold Coast world, were the things they now felt they could claim for themselves — Ghanaian, English, or otherwise? If all progress originated outside Africa, as had been implicitly driven into them, what did a technological future have to do with them? As my parents sat in that sweltering California apartment, watching on a black-and-white TV the first man to take his steps on the moon, they wanted to feel that feat as part of their own story and didn't understand why it felt so elusive and distant from them. American men in their white spacesuits, speaking with the slowness of ghosts as they bounded across the dull grey dust — was this future also theirs to own?

2

FIVE YEARS BEFORE THE moon landing, a grade school science teacher in Africa's newest ex-colony had already taken up the cause of space exploration. It was October of 1964, and the British protectorate of Northern Rhodesia had just claimed its Independence, the country renamed Zambia after the clear waters of the grand Zambezi River that sources the Victoria Falls. Foreign media arrived in the nation to report on the raucous, jubilant celebrations. But *Time* magazine also made mention of a man who found the partying an annoying distraction. He was Edward Makuka Nkoloso, the director of Zambia's National Academy of Science, Space Research

and Philosophy. And he wanted to talk only about his space program.

The Space Race had always been viewed through an East/West lens, as a two-way competition between the United States and the Soviet Union. But five years before Neil Armstrong took his first steps on the moon, Nkoloso was already trying to blow apart that narrative. He had founded his program with the aim to best both the Americans and the Soviets by putting a man on the moon by the end of 1965. "Already Nkoloso is training twelve Zambian astronauts," the *Time* article read, "including a curvaceous 16-year-old girl, by spinning them around a tree in an oil drum and teaching them to walk on their hands, 'the only way humans can walk on the moon.'"

The strangeness of these details sent a frisson through the worldwide media. Many wondered if the whole thing was in fact an elaborate joke. In the following months, both British and American journalists would be dispatched to Zambia.

Taken together, Nkoloso's interviews give a clear picture of his space program — despite his desire to shroud it in mystery out of fear of having his technology stolen. His initial team of astronauts was made up of ten young men and Matha Mwambwa, the sixteen-year-old girl mentioned in the article. Nkoloso called them his "Afronauts." In recognition of the pageantry and showmanship that usually accompanied such grand feats, the Afronauts sometimes dressed in shiny green

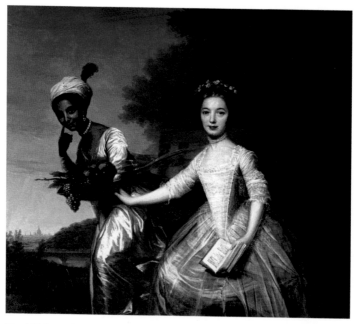

David Martin's *Portrait of Dido Elizabeth Belle Lindsay and Lady Elizabeth Murray.* Both orphaned, the second cousins were sent to live in the household of Lord Mansfield. The white turban on Dido Belle's head linked her to notions of "the Orient."

An architectural plan for Herman Wallace's dream house in Louisiana.

jackie sumell's reconstruction of the cell in which Herman Wallace lived in solitary confinement at the Louisiana State Penitentiary for over forty years.

Herman Wallace's correspondence with jackie sumell.

WOW!!! Great visit that one was. I often tell people what is perceived as a bad thing is not necessarily bad at all. Your not being able to get in to visit on the following Friday turned out great for two reasons. It gave you a chance to return to tell me of your feelings of land-picking up story began in search of a home for then, but what about the painting of the two wonderful ladies who got the chance to meet the incredible, legendary Jackie Sumell!!? They were so surprised when you tell them your name "Jackie Sumell! The House That Herman Built." And knowing you, when she said that, I know you were in shock—in a good way. It was a perfect moment and had it not been for your decision to wear the A3-T shirt, you would had never met them. I wish we could had made the effort to get Angad in to visit on a special visit pass. I didn't know until you got here he would be traveling here with you. Anyway, the visit was awesome & I think we covered a lot of real estate in both categories.

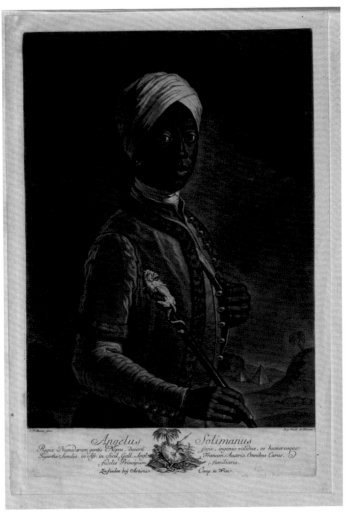

Johann Gottfried Haid's *Portrait of Angelo Soliman*. Born enslaved, Soliman eventually made his way to Vienna where he became a much-admired courtier and a reformer of Freemasonic thought throughout Europe.

Kehinde Wiley's
*Napoleon Leading the
Army over the Alps*

Jacques-Louis David's
Bonaparte Crossing the Alps

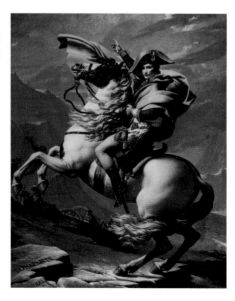

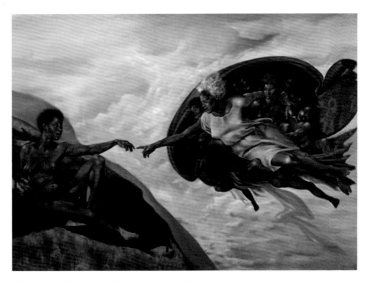

Harmonia Rosales's *The Creation of God*. A re-envisioning of
Michelangelo's *The Creation of Adam*, the painting caused a stir when
first exhibited due to its depiction of God as a Black woman.

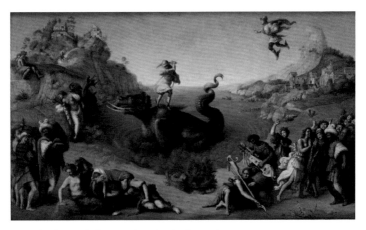

Piero di Cosimo's *Perseus Freeing Andromeda*

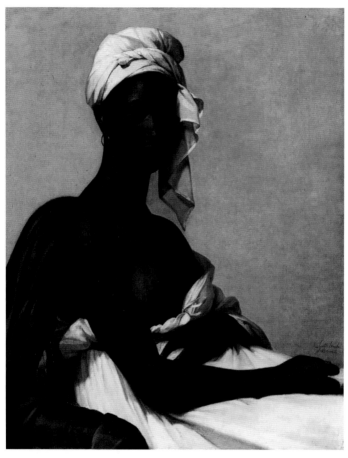

Marie-Guillemine Benoist's *Portrait of Madeleine* was formerly known as *Portrait of a Negress*.

From *Imitation of Life* (1934), directed by John M. Stahl. The film depicts the fraught relationship between Delilah (Louise Beavers) and her light-skinned daughter Peola (Dorothy Black), who chafes against her Black identity.

From *District 9* (2009), directed by Neill Blomkamp. The controversial film used elements of science fiction to explore the race hatred, xenophobia, and segregation of South Africa's apartheid era.

jackets and yellow pants, which doubled as a uniform for the rock band they played in during their off hours. Nkoloso himself often wore, over his military fatigues, a flowing silk or velvet cape adorned with embroidery and medals.

The senior Afronaut was twenty-one-year-old Godfrey Mwango; he had reportedly completed more space training than the others. Second to Mwango was Matha Mwambwa. Under Nkoloso's tutelage she had been studying chemistry, astrophysics, geography, cosmography, and astro-biology. She had also been appointed to care for the program's ten cats. When asked why the cats were needed, Nkoloso revealed that his space program had grander plans than a mere moon landing. Zambia would also be the first country to colonize Mars — and Mwambwa would be the one to do this. The cats had a twofold use. First, they were to provide Mwambwa with company on the long journey. But more importantly, they were technological accessories. When Mwambwa arrived on Mars, she was to open the door of the rocket and drop the cats out. If they survived, she would know that Mars could sustain human life.

A third Afronaut was a twenty-two-year-old man whose future mission was yet to be chosen, for the simple reason that Nkoloso wanted to wait until Mwambwa had returned from Mars so that he could reuse her spacecraft. Nkoloso called his first rocket the DKALO-I, in honour of Zambia's first president, Kenneth David Kaunda,

who had been a dear friend during the revolutionary years as the two men fought together in the struggle for Independence. The craft was a ten-by-six-foot copper-and-aluminum forty-four-gallon oil drum. More drums were amassed, and the astronauts were loaded into them and rolled downhill to simulate the sensation of hurtling through space. To replicate zero gravity, Nkoloso would have them swing from the end of a long rope, and when they reached the highest point, he would abruptly cut it, sending them into freefall. This was called the *mulolo*, or swinging, system, and Nkoloso implied that *mulolo* in and of itself might be a viable means of getting into orbit. "We have tied ropes to tall trees and then swung our astronauts slowly out into space," he explained. "Thus far we have achieved a distance of ten yards. But of course by lengthening the rope, we could go further."

An article in the *San Francisco Chronicle* described a scene in which "the first Zambian astronaut was successfully placed in orbit at 3:14:32 PM central African time." A final countdown had to be interrupted twice because of technical difficulties — the difficulties being that Godfrey Mwango was too large for the barrel he'd been placed in, so that his head kept popping out and swinging perilously close to the ground. He finally scrunched himself low enough for Nkoloso to be satisfied. "Blast off!" Nkoloso yelled, kicking the drum with his foot. "All systems go!"

Mwango is described as "orbiting" seventeen times down a grassy slope before coming to rest against a blue

gum tree. When the journalist asked Nkoloso what he'd learned from the test, Nkoloso replied, "Well, for one thing, we're going to have to get a bigger barrel."

Nkoloso himself published an editorial late in 1964 which can be found online, with the title "We're Going to Mars! With a Spacegirl, Two Cats and a Missionary." In it, he wrote:

I see the Zambia of the future as a space-age Zambia, more advanced than Russia or America . . .

We have been studying the planet through telescopes at our headquarters and are now certain Mars is populated by primitive natives. Our rocket crew is ready.

Specially trained space girl Matha Mwambwa two cats (also specially trained) and a missionary will be launched in our first rocket.

But I have warned the missionary he must not force Christianity on the people in Mars if they do not want it . . . we can lead world science.

He ends the article by claiming that Russian and American spies have long been operating in Zambia, with the goal of trying to steal his program's secrets and kidnap Mwambwa and the cats. Nkoloso estimated needing £700 million to reach the moon's surface; adjusted for inflation, that would be approximately $21 billion Canadian today. Having managed to raise only C$2,800 in private donations, Nkoloso petitioned

the United Nations to finance the early phases of his work. Despite his secrecy, he welcomed reporters into the space program's headquarters, a base that changed location depending on his day job, but which was usually a room stuffed with space memorabilia. Nkoloso told the Associated Press: "Some people think I'm crazy, but I'll be laughing the day I plant Zambia's flag on the moon."

OF COURSE THE AFRONAUTS never travelled to Mars, or the moon. Not long after the blitz of Western interest, the astronauts began to abandon the program. Nkoloso complained bitterly that the attention had gone to their heads; they had refused to continue unless paid. He lamented that the youth had lost their concentration, turning their focus instead to lovemaking. In fact, his star astronaut, Matha Mwambwa, became pregnant, so her parents insisted she discontinue the physically rigorous training. Nkoloso added: "Two of my best men went on a drinking spree a month ago and haven't been seen since. Another of my assets has joined the local tribal song and dance group. He says he makes more money swinging from the top of a forty-foot pole." Nkoloso claimed that his main rocket was sabotaged "by foreign elements," and that the "imperialist neocolonialists" were frightened of Zambia's space technology.

It is easy to see the absurdity of this story. But what if the joke was on us? The novelist Namwali Serpell wondered as much in a 2017 piece for the *New Yorker.* She questioned

why so few in the West have imagined that the Zambian space program could have been a satire. Nkoloso was a figure of affection in Zambia, best known for his role as a revolutionary but also for his humour. During his work as a trade unionist, he disguised himself in women's clothing and paraded before colonial officers, asking them what they knew about a man called Edward Nkoloso.

His story asks us to confront our own laughter: to examine not just *why* we are laughing, but *how*. In the 1960s, the most jarring laughter carried within it absolute disbelief at the idea that Black ingenuity might put mankind into space. We know now, of course, that Black scientists were essential — the work of American mathematician Katherine Coleman, for example, was partially responsible for sending the first Americans into space and into orbit. Dorothy Vaughan and Mary Jackson were among many who made crucial contributions in their roles as human computers at NASA, the National Advisory Committee for Aeronautics, and the Langley Research Center. But even to list these incredible achievements wrongfully legitimizes the thesis one is being asked to counter in the first place, by accepting its terms. It is enough, I think, to say that certain Western thinkers saw technological progress as a future bound by race. In her article, Serpell makes reference to the journalist and far-right British political activist A. K. Chesterton, who used Zambia's space program as proof that Africans were too naïve for self-government. In his 1965 book, *The New Unhappy Lords*, he wrote that "the

masquerade of the African in the guise of a politician able to take over the running of a modern state . . . has nowhere been demonstrated in a more ludicrous light than in Zambia . . . What other country in the world, for example, boasts a Minister of the Heavens?" The more outlandish aspects of Nkoloso's program were fodder for the prejudices of conservative critics.

Even those governing the new Zambia sought to play down Nkoloso's intentions. In 1970, the acting press officer at the Zambian embassy in Washington, DC, stated, "Nkoloso is actually a very well-read person . . . It was a big joke." Similarly, in a 2017 interview, former president Kaunda, for whom the first rocket had been named, explained, "It wasn't a real thing . . . It was more for fun than anything else." Both verdicts would seem to confirm the theory that the program was a satire. But they also reveal an instinctive embarrassment, a desire to not have Nkoloso stand as the definitive emblem of a nation many Westerners know little about. While Nkoloso's true goals remain obscured, there can be no doubt, in any case, about the sincerity of purpose with which he went about recruiting and training his astronauts. Considered alongside the chaotic past he shared with his budding nation, the story of his space program takes on an increasing seriousness.

EDWARD NKOLOSO WAS BORN in 1919 in the north of what was then Northern Rhodesia, a landlocked territory in the southern region of Africa. The first Europeans had

arrived in a Portuguese expedition led by Francisco de Lacerda, in the late eighteenth century. Other Europeans would follow in the nineteenth century, including, most famously, Dr. Livingstone, the contentious Scottish explorer and Christian missionary who would eventually go missing along Lake Tanganyika and be found by Henry Morton Stanley. By the late nineteenth century, British mining magnate Cecil Rhodes had arrived in the region soon to be renamed for him, becoming prime minister of the Cape Colony and plundering the region's natural mineral resources. The area would later be absorbed into the British Empire.

Nkoloso took a missionary's education in Latin, French, and theology, with plans to join the priesthood. But at the outbreak of World War II, he was drafted by the British to serve in their King's African Rifles unit, and then promoted up the ranks into the military's communications arm, the Signal Corps. During these years he was introduced to new technologies, learning, among other things, how to use advanced microscopes. The experience engendered a lifelong passion for science and technology.

Nkoloso returned from the war to discover that, despite having fought for the cause of European freedom, he was himself no freer. Any improvement of the raw conditions in which Black people lived in his country, any possibility for broader advancement, remained as out of reach as ever. He worked first as a translator for the Northern Rhodesian government, and when that did

not work out, applied for a permit to open his own school. The colonial administration denied it. Outraged, Nkoloso went about opening it anyway. It was swiftly shut down. He then went from one government-sanctioned school to another, teaching Latin, math, and science.

Nkoloso joined an advisory council and began airing his progressive views more widely. He lobbied for better education for the Black population, requesting that a technical and industrial college be built, as well as a maternity clinic. He organized a civil disobedience campaign against the colonial administration, once storming the offices of the district commissioner to speak out against a European foreman who was digging up African graves. For such activities he was arrested and convicted. After his release, he enacted larger-scale campaigns, fighting against both the colonial administration and local tribal chiefs by encouraging workers to walk off their jobs as waiters, as couriers, as farmers of the chiefs' fields. He organized street marches, using road blockages and even arson to drive home his message. With his scientific knowledge he built bombs and other weapons. He was repeatedly arrested, and the authorities allegedly beat up his parents in their home. His aunt was also taken into custody, and she died in prison two weeks later. The authorities seemed to want to make a particularly brutal example of his family, illustrating with all their force what it meant to defy colonial law.

In 2017, Nkoloso's son revealed a shadow narrative

underlying his father's space program. The Afronauts, he claimed, were being trained not simply for space missions but as fighters in the cause of freedom. They were part of a covert resistance movement against the tyrannical colonial and native authorities. Godfrey Mwango and Matha Mwambwa had reportedly travelled to Tanzania to broadcast censored political screeds. They had written graffiti promoting Kaunda's United National Independence Party, and had even been trained to make simple explosives, using them to strategically take down bridges. And so his program was possibly both a real attempt at technological innovation and a hidden political operation.

But murkier resonances remain. At the time of the program, Zambia's population numbered 3.6 million, with barely 1,500 African-born high school graduates and fewer than one hundred college graduates. By that measure, Western perception would have held that "progress" had overlooked Zambia. In his infamous editorial, Nkoloso concluded that "the capital of the new scientific Zambia must look beautiful. People from afar must not see a slum as the capital of the world's greatest state." He proclaimed that Matha Mwambwa would be "the first coloured woman on Mars," and that "our posterity, the Black scientists, will continue to explore the celestial infinity until we control the whole of outer space." The symbolism of launching the Black body into space at a time when life on the ground was untenable is deafening.

It is difficult not to read his many declarations as both an anxiety under, and a casting off of, the Western gaze. If one of the measures of evolved societies is the constant advancement of their technologies, as Nkoloso seemed to feel, then he needed Zambia to be able to compete on those terms, but he needed also to toss the terms aside. Rather than passively play out Cold War affinities based on old colonial ties, Zambia would put itself on equal footing with Empire, and would answer only to itself. "What they can do, we can do also," Nkoloso declared, but the doing would be on Zambia's terms. Those terms might not be fully comprehensible to Western judgements, he suggested, or co-align with Western customs, but carried within them the integrity of indigenous values. Those values would seem to include an element of satire, the sharp awareness that all human striving is inherently absurd but still worth the doing. They would also include the cloaking of one's true work in smoke and mirrors, for without such subterfuge, one's resources are vulnerable to theft, a lesson made only too clear in his country's legacy. Nkoloso's was both an absurd, grand act of self-creation and a concrete rejection of unchanged post-war inequities. He aimed to change the present by changing the future.

NKOLOSO'S AND MY PARENTS' stories feel like divergent strains of the same narrative — or perhaps like shadows of each other. All three were born in colonies of the British Empire and came of age in nations suddenly,

passionately, transformed. Each was a child of science, with hard faith in calculation and measurement as tools of order and grand dreams about how that faith would change their life. Each had been raised in systems whose acknowledged achievements were British and whose histories were obliteratingly so: as a child, my mother could name practically every prime minister since Pitt the Elder but would falter on the geography of her own continent.

Where their stories diverge is in the nature of how they went about tackling the future. If lives were novels, my parents' would carry within them the logic of nineteenth-century plots, something of the rags-to-riches strivings of Trollope's characters, with their abandonment of socially claustrophobic worlds for ones of even more bewildering exclusion. Nkoloso's novel, by contrast, has the chaos and bent reality of speculative fiction, but the purity of myth also. He elevates his hopes for an African future into the realm of metaphor. My parents are the pedants, working towards their dreams in academia, for them the only known road to advancement; Nkoloso is brash and operatic, stabbing at the dark. What they all share, in the end, is a fierce forward look, an obsession with the future that, though they may not have recognized it, carries within it the desire to connect more deeply with an African past. The British historian Hugh Trevor-Roper famously said, "Perhaps, in the future, there will be some African history to teach. But at present there is none, or very little: there is only

the history of Europeans in Africa. The rest is largely darkness." My parents and Nkoloso each understood the falseness of that narrative: they hoped instead to locate the African within Africa, not the English histories that had sought to define it. And that knowledge would allow them to imagine a new future, one powerfully African, and in that very act of creation reimagine a past from what has been suppressed.

3

HOW CAN A COMMUNITY whose past has been deliberately rubbed out go about imagining a future for itself? Mark Dery asked this in 1994, as a way of exploring African histories and cultures and their intersection with technology. He coined the term "Afrofuturism," which at first sought to define African American science fiction but broadened to include not just the entirety of the African diaspora but a kind of philosophy and personal ethos.

The word "Afrofuturism" likely brings to mind films like *Black Panther* and *Get Out*, movies in which the impact of technology on Black lives is writ large. As the writer Ytasha L. Womack explains, it is "an intersection of imagination, technology, the future, and liberation" that combines "elements of science fiction, historical fiction, speculative fiction, fantasy, Afrocentricity, and magic realism with non-Western beliefs." In literature, we think of the novels of Octavia Butler, Nalo Hopkinson, or,

more recently, N. K. Jemisin and Karen Lord; in music, of the self-consciously metaphysical sounds of Sun Ra, George Clinton, Janelle Monáe. But in its casting backwards to co-opt historical events and art created before the term was born, it has exploded its theoretical borders to embrace not just the novels of Ralph Ellison and the paintings of Jean-Michel Basquiat but also an event like Zambia's space program and figures such as Ed Dwight, who in the 1960s trained to be America's first Black astronaut. Some have argued that Afrofuturism has left the realm of arts and criticism behind entirely and become something of a global movement and philosophy. However one chooses to view it, it has clearly served to illuminate the conflicts and possibilities of imagined worlds as a means of getting us to confront the conflicts and possibilities of our own.

Dery's question suggests that being able to imagine yourself in the future at all is a radical act in the aftermath of having your history suppressed and extinguished. To have the full sense of what's possible for your future, you must have a sense of the past, a reality that was and remains difficult or even impossible for many people of African descent in the shadow of slavery and colonialism. So many ancestral customs have been lost, so many family bonds, rituals, languages, names. Beyond the breaking of the Black body were subtler but no less devastating attacks — deliberate, systematic efforts to destroy the binding memory of culture.

It is uncanny how much science fiction tropes align

with some of the features of Black life — tropes like forced dislocation; men arriving in alien worlds; aliens arriving into societies of men in which they will be experimented on and under attack. Dery argues that African Americans are in a very literal sense "the descendants of alien abductees; they inhabit a sci-fi nightmare in which unseen but no less impassable force fields frustrate their movements; official histories undo what has been done; and technology is too often brought to bear on black bodies (branding, forced sterilization, the Tuskegee experiment, and tasers come readily to mind)." The condition of being alienated and "othered" reflects the ways in which navigating Western societies as a Black person is an endlessly unsettling experience, something that might be ripped whole from the pages of a speculative novel. Because of this, the search for lost cultural touchstones is a gesture towards survival: it is an Afrofuturistic act. At its heart it is the creation of a possible future based on a reconstructed, or reimagined, past. In this way, a war is waged against erasure.

ART, TOO, IS A defence against erasure. The best of it will always outlive us. Whether Ryan Coogler's 2018 film, *Black Panther*, falls into the category of art, or whether it's merely an imaginative but commercial product, or something in between, is still being debated. But it feels nearly impossible to speak of Afrofuturism without confronting this most central of films.

Black Panther is a story of crisis, set in the fictional country of Wakanda. Wakanda is a kingdom in the heart of Africa that has never been colonized by any Western power. To the outside world, it is one of the poorest countries in the world, making its refusal of international aid puzzling. But literally behind its surfaces, as one plunges into the realm hidden beyond its lush green jungles, Wakanda is the most technologically advanced society in the world. Divorced from all Western technological progress, it has, on its own terms and through its own ingenuity, developed technical marvels that far outpace anything seen elsewhere. What would an African nation spared slavery and colonialism look like? Coogler's answer is much the same as Nkoloso's: powerful almost beyond imagining. Had Africa's mineral wealth not been plundered, had its people not been enslaved and made subjects, the possibilities for its future would be limitless.

Wakanda must negotiate a difficult balance: for centuries it has been isolated from even its neighbouring nations — this is what has assured its safety. And yet some on the king's council disagree with this isolationism, seeing it as their duty to help any African country suffering famine and disease. But it is not simply a matter of exporting its own resources altruistically: to expose Wakanda's riches to foreigners is to open its people to attack and plunder, a fact that Edward Nkoloso understood only too well coming of age in Rhodesia. At particular issue is vibranium, the most powerful element in the world, an alloy perfect in form and wholly

indestructible. The fight over vibranium gives the plot its breathtaking velocity, but this is just one of the film's many surface stories.

For all of its superhero movie tropes — the noble, if reluctant, protagonist; the charismatic, powerful antagonist; riveting fight sequences — it is one of the few such films that attempt to reach for deeper issues. In constructing a prosperous future based on an imagined past, Coogler forces us to confront in a very visual, inescapable way exactly what might have been lost through the devastations of history. His is not a literal rendering, but it could be, he suggests. Yes, vibranium is a fantasy, but so much of the power of the film's worldbuilding comes from what is rooted in actual history. In this way, we're shown what technological progress of a uniquely African origin might have become had it not been disrupted.

The *kimoyo* beads, for example, that adorn Wakandans' wrists are suggestive of the cowrie shell or bone bead jewelry worn for centuries across many regions of Africa, yet they also act as advanced tech, trilling like Apple Watches and throwing out bright holograms. The shimmering glass skyscrapers of Golden City have the technological grandiosity of the world's most impressive steel-and-glass towers, but they are topped with the thatched rondavel roofs that for many centuries have adorned the homes of the Indigenous Peoples of Southern Africa. Traditionally these were constructed of dead and living grass and plant stems sewn together with ropes

also of made grass, and attached to poles. That the tech-
nique has been preserved in futuristic Wakanda speaks
to the essential integrity and soundness of its centuries-
old engineering. The buildings' designs also reference
textures from the pyramids of Mali and scaffolding
used in the ancient buildings of Timbuktu, which was
a major centre for religious study, the arts and sciences.
In the Middle Ages, Mali established three great philo-
sophical schools — Sidi Yahya University, Djinguereber
University, and the University of Sankore — the latter
of which eventually came to house the most extensive
collection of books in Africa since the great library of
Alexandria, which was itself the largest library in the
classical world, founded in the third century BC.

Most fascinating, perhaps, is Wakanda's female royal
guard, the Dora Milaje. They are a clear nod to the
so-called Amazons of the Kingdom of Dahomey. From
the seventeenth to the nineteenth century, all-female
infantry units acted as the king's guard. They were
called Minon, a Fon word that translates to "our moth-
ers," and had originally been recruited to hunt elephants.
The youngest among them were just eight years old.
They are said to have been instrumental in defeating
the Kingdom of Savi in 1727. Biological warfare was used
extensively, usually in the form of poisoned arrows but
also as chemicals strategically laid across the terrain at
the front and poured into wells and other watering holes
the enemy or their horses might drink from. The Minon
were considered valiant and fierce, feared deeply by both

neighbouring kingdoms and the Europeans on the coast. In 1733, a European trader wrote that "the simple rumor of their approach makes people drop everything and flee."

As I watched *Black Panther* with my father, his reaction was enlightening. After fifteen minutes or so, he burst out laughing. He was enjoying it immensely, he said, "but where are these people *from*?" Their accents seemed to convey some vague lilt of the Africa of the West, sometimes of the East, sometimes of the South, sometimes of the centre. They shifted constantly, sometimes within the same scene in the same character's mouth. He took this as a kind of disingenuousness, and also as part of the entertainment. The jungle lushness of Wakanda's hills was hallucinogenic, as was the uncorrupted beauty and nobility of its people. All of this he laughed at, and all of this he loved, unused to, perhaps, such a positive vision of Africa on an American screen.

That, I understood, was the point. The Africa of Wakanda is not Africa at all, but a diasporic fantasy of the Africa that might have been. It is the vision of a pan-African future in which progress has been allowed to play out without destructive meddling from outside, the vision of Edward Nkoloso brought into full maturity. Isolation does not, of course, create a utopia; it does not forestall other problems. But Wakanda leaves us with an exquisite dream of freedom, of a people allowed to live out some version of wholeness.

4

MY MOTHER PASSED AWAY on a bright winter's morning in a Calgary hospital. That was twenty-four years ago. The death was sudden, and quiet, I'm told — I was not there. I was studying at university, as she had once done, living hundreds of miles from home in a squalid apartment, in Victoria, with two other arts students. Through the orange-lit hallways moved strange, evasive figures who clipped their toenails onto the foyer rug and, when their power was cut, plugged extension cords into the hall sockets to run under their doors. It was a building of grifters, students, the unlucky. A smell of soup clung to the air, as if boiled across generations. Dust nestled in clots along the baseboards. From our basement suite you could just make out, through tiny, high windows, a view of shoes walking the damp streets. It was not my happiest life, but I was living it, freed from any of the heavier burdens of adulthood — until, at least, the call came about my mother.

After the funeral I returned to student life and to a strange series of happenings around our apartment. A sturdy chandelier suddenly gave way, shattering on our kitchen table. The wood floor began to creak at uneasy hours. Once, while home alone, I passed our front door to find the security chain placed across it. I took it off, only to pass by an hour later and again find it latched. My mother had been a fanatic when it came to security. Constantly throughout my childhood, in an easy

rhythm, she'd walked about locking and latching things.

It seemed, in those solitary moments, that her ghost had found me. It also seemed that I, or simply chance, had caused the events, however impossible it felt at the time. I understood then that I was haunted in ways I could hardly discern, as my mother had been haunted. I realized she'd gone about her life in just this state of unease, a sense that a past not visible but wholly alive was asserting its presence.

In those months of grief, which became just a blur of movies and books, I happened on a late-night screening of Ridley Scott's *Blade Runner*. As I watched the tail lights of hovering vehicles pass through in the film's rain, and replicants and grizzled blade runners drift through the neon-lit streets, I felt intensely lost, not just in the story but within my body, as if unable to locate the source of my thoughts. I had become unmoored from myself. I felt how heavily, how deeply, my past was lost to me, how sharply it had all been severed, until I could only live alongside its absence, both aware of it and disconnected from it. I felt, in those moments, like a lapsed African, cut off now from the source of what had made and kept me African — for though it was illogical, I viewed my mother as my lifespring; it was from her I had acquired all of my qualities. I also understood how I had essentially never been African, but rather of African heritage, as though some page had been skipped. I got so mired in these distinctions, so twisted up in trying to figure out what I had become, if I was any different. Only now do I see in the

uncoupling from the certainties of home and culture that her death represented, in the way time had made what once belonged no longer belong, the same things I see in Afrofuturism. A new life must be built on the ashes of an old one, with a slowly fading idea of what has been lost. With the years, it has become difficult to remember my mother's voice. Afrofuturism is the story of dislocation.

But it is also the story of recovery, of finding new anchors. Once the past has been extinguished, a future based on its memory is not only the path forward but a commemoration.

5

IN NNEDI OKORAFOR'S 2014 NOVEL, *Lagoon*, the author uses an alien visitation to explore issues of cultural centrality and disconnectedness. We are so used to such narratives playing out in the large Western cities of New York, Los Angeles, or London that the fact of the spacecraft's landing in Lagos, Nigeria, cannot help but feel subversive. Okorafor lays out what a distinctly West African version of this event would look like, limning local reactions and complications. Her tools are not the expected ones. There are no space-age gadgets, flying cars, or robots. Instead, she aims to show us how a society outside the centre would grapple with invasion — a society which in fact already has a long history of besiegement. As Okorafor wryly writes, "This wasn't the first invasion of Nigeria, after all."

Okorafor, an American of Nigerian descent, penned the novel partly in response to the work of another continent-straddling artist: South Africa–born, Vancouver-based Neill Blomkamp. Blomkamp's 2009 film, *District 9* (co-written with Canadian screenwriter Terri Tatchell), is a visceral tale of alien visitation in Johannesburg. Upon release, the movie stirred as much outrage as admiration. Much of the controversy centred around representation — most pointedly, the very unflattering depiction of Nigerian people. Before touching on that, however, and the nature of Okorafor's response, it is interesting to note what their art has in common. Both seek to decentralize the narrative of extraterrestrial contact to access specifically African histories and social issues. Both cast off many of the expected Western tropes. And both reach beyond cliché to explore, as the critic A. O. Scott wrote of *District 9*, not what aliens would do to humans, but what human beings would do to aliens. To that I'd add a fascination with what human beings would do to each other. Indeed, both Okorafor and Blomkamp gesture towards the long centuries of human brutality, and what we continue to mete out.

District 9 drops us into modern-day Johannesburg, where an enormous spacecraft has remained stalled in the city's skies since the 1980s. The government has discovered a society of half-starved robotic creatures on board — beings they came to derogatorily call "Prawns," due to their writhing, crustacean faces, their strange blending of shell-like bodies with machinery. They were

"rescued" from their ship and placed in a refugee camp called District 9, where for the past twenty years they have lived in squalor and destitution. Despite the fact that their technology suggests they come from a more advanced society than our own, they are derided as a filthy, useless, backwards caste, despised by all South Africans alike.

The film opens in the midst of the government's attempts to relocate the Prawns to a second refugee camp. One of the aliens, Christopher Johnson — a pointedly colonial name — has planned to escape with his son and leave Earth for their home planet. Over the years, he has been slowly collecting fuel from a local garbage dump to eventually power up a dead spacecraft that will return them to the mothership. One day, a lowly government bureaucrat called Wikus van de Merwe shows up. He works for the symbolically named Multi-National United (MNU), one of South Africa's largest weapons manufacturers. The corporation has also been granted government contracts to house and relocate the Prawns. During an inspection, Wikus discovers Christopher's secret trove of fuel. While trying to confiscate it, he accidently sprays some of the black liquid into his own face. Thus begins his transformation into one of the hated race — a Prawn — as first his arm, and then the rest of his body, starts its slow metamorphosis.

MNU gets wind of Wikus's transformation, and he is taken to their labs. After discovering the company's horrific program of medical experimentation, he escapes,

making his way back to District 9, where by chance he stumbles into Christopher's home. The two have a heated argument, but it eventually becomes clear that each can achieve his goal by helping the other. They agree to ascend to the mothership together, where Christopher will cure Wikus and then fly home with his son. As with any story of high drama, though, every complication is thrown their way.

Not unlike *Lagoon*'s, it is the movie's metaphors, its shadow stories, that resonate. Anyone with even the barest knowledge of modern history cannot fail to see the apartheid allegory, the xenophobia and race hatred filtered through an otherworldly morality play. The title itself alludes to District Six, an urban residential area in the heart of Cape Town that in 1966, under the Group Areas Act, was declared "whites only," so that sixty thousand Black people were forcibly moved twenty-five kilometres away, to the Cape Flats. I remember visiting the Cape Flats some years ago and being shocked at the deprivation, the rusted shipping-container homes, its stark divide from the high hilltop houses with sprawling ocean views just an hour away. *District 9* gestures towards this startling dissonance, and to the general ghettoization of Blacks in post-apartheid South Africa, with their forced removals and "temporary" relocations.

The movie was filmed on location in the township of Chiawelo, in Soweto, during a spate of violence that saw indigenous South Africans attack illegal immigrants from neighbouring African nations. Within his

apartheid allegory, Blomkamp sought to expose these other tensions. But from this depiction of the animosity between Black Africans, and the harshness of Nigerians in particular, controversies arose. Almost to a person, his Nigerians are gang members, weapons dealers, prostitutes, and even — in a scene in which gangsters eat alien flesh because they believe it will grant them good health and the power to operate Prawn weaponry — cannibals of a sort. Blomkamp told the *New York Times* in 2009 that he'd been concerned about how American audiences might respond to these portrayals. "It could leave a bunch of North Americans feeling either confused or insulted," he said. "I could see the same scene in South Africa being watched almost as though you're watching a piece of the news."

This, if it says anything, speaks to the way the South African media might then have sought to portray outsiders. But it also raises the question of why Blomkamp should concern himself more with an American response than an African one. In Nigeria, protest letters were sent to the film's producers and distributor. The minister of information petitioned to have the movie banned, or at least to cut all references to the country. She pointed to the fact that a lead gang member called Obesandjo has a nearly identical name to that of the country's former president Olusegun Obasanjo. The Nigerian Film and Video Censors Board was tasked with confiscating the film, which was eventually banned in that nation.

I am hardly an advocate for censorship, but the criticism is warranted, at least in part. While the film remains deeply admirable — brilliant, in fact — the Nigerians amount to simple agents of darkness, and their viciousness shores up a narrative of Black tyranny hovering beneath the story. In Blomkamp's futuristic world, Blacks are as much a part of the machinery of oppression as whites: Black officials are involved in the relocation and containment of the Prawn population; local Black citizens speak with urgency about the need and justification for segregating the aliens. In the context of an apartheid allegory, if you extrapolate, it suggests that had the roles been reversed, Blacks would have behaved no differently than whites. Yes, human behaviour is universal, but to make such a point within this particular metaphorical context is to imply that earlier generations of white South Africans deserve some measure of absolution, because anyone would have enacted that system. This is likely not Blomkamp's intended effect, but it is there nonetheless, ghosting the story.

6

LAGOON RESPONDS BY PUTTING Nigeria at the centre. This is not to say that the novel is purely a rebuttal, that it works only on that level — it is uniquely, chaotically itself. As Lagoon opens, three people walk along Bar Beach in Lagos. Adaora, a marine biologist, is reeling after being struck by her husband; the soldier Agu

has just assaulted his military superior; Anthony is a Ghanaian hip hop artist whose work draws from the legacy of the griots. Unknown to each other, consumed by their own thoughts, they are all three suddenly swept out to sea by a rogue wave. When they finally make their way ashore, they find themselves in the company of Ayodele, an ambassador from another world, who can mimic the human form. She and her fellow extraterrestrials have specifically chosen Nigeria as an ideal place to live, attracted by its energy and potential.

Of course, the presence of aliens in Lagos cannot go unnoticed by the locals for long, and their arrival wreaks havoc in ways both expected and surprising. Lagosians project their own desires onto the visitation, so that beyond the usual chaos and fear arise conflicts that feel distinctly West African. A group of 419 boys — 419 being the section of the Nigerian criminal code for internet and phone scams — plot to kidnap Ayodele and look to profit somehow. An underground LGBTQ group believes the invasion heralds a revolution. A rich evangelist obsessed with growing his congregation hopes to use the aliens to expand his church into the heavens — which feels rather like a reversal of Edward Nkoloso's vow to forbid his missionaries from converting the natives of Mars. In a kind of commentary on the ineptitude of local government to respond to crises, the Nigerian president, well meaning, fails to take control of the situation, his military growing ever more threatening, his actions ever more uncertain. In a

droll inversion of the classic extraterrestrial encounter, upon meeting the aliens, it is the president who utters the words "Take me to your leader."

Okorafor shows us the vibrancy of the real-world Lagos, with its traffic and beachside nightlife, its hip hop culture, cafés, and chaotic markets. She also pries open a shadow Lagos, one populated by creatures of West African folklore and myth: Udide Okwanka, the Igbo trickster spider (much like the Anansi of Ghana); Papa Legba, another trickster deity, horned and phallic; a Bone Collector, a sentient road whose features draw on traditional ideas of animism. The Bone Collector is an asphalt monster that wakes to devour those passing over it. It is based on the Lagos-Benin Expressway, a treacherous stretch of highway on which thousands of fatal accidents have taken place.

Ayodele herself is an incarnation of Mami Wata, a water god known throughout the African diaspora, emerging as she does out of the ocean. That that ocean is inevitably the Atlantic also links Ayodele to the Middle Passage, touching upon slave histories. She is a shape-shifting alien whose anatomy is comprised of microscopic metal beads, giving her a plasticity that allows her to take on any shape, though her preferred form is the human. Her transformation is a powerful tool, and in this way Okorafor makes the connection between slave histories and science fiction. There is the emphasis on the body, on what it means to have agency over it; there is the nod to the way others' perceptions

of that physicality have governed so much about how Black people have been able to navigate society. The slave trade introduced new technologies to subdue the body, and one of the chief preoccupations of speculative fiction has always been the ways that technology can be used to enhance or suppress the vulnerable human form.

One of *Lagoon*'s greatest charms is the extended joke about the invisibility of "developing" nations. Lagos, a city of around fifteen million people, is invaded by aliens and at first no one else in the world notices. Foreigners' knowledge of Lagos, the author implies, is usually restricted to its booming oil industry, its offshore drilling. Westerners only grow aware of the invasion when online footage goes viral. Even then there is no great sense of common threat — the invasion is happening "over there," and as such has no consequence for "first-world" lives, despite the obvious fact that it represents a huge turning point in human history. This visitation is happening on the margins, and is therefore barely remarkable. At best, it is entertainment. Okorafor emphasizes how centrality, or a lack thereof, informs what is considered newsworthy, which in turn affects how it will go on to inform, or disappear from, our global collective memory.

Lagoon is a powerful parable of the future, limning the ways our stories make, or fail to make, history. What will recorded history look like if even an event of this magnitude in Africa is ignored by the rest of the world? This sidelining is precisely the kind of thing that has led

to the erasure of the past; it is the willful dismissal that encouraged historians like Hugh Trevor-Roper to view Africa as an area of darkness. In fact, one could argue that the longest-running battle in the history of world conflicts is the one waged over the supremacy of stories. The dominant narrative tilts the axis of memory—its triumph is the triumph of being seen. Faced with this reality, then, Afrofuturism purposefully invents a future based on what has been destroyed through ignorance, recreating a past as it builds a startling new world of the possible.

7

IN THE SUMMER OF 2007, ten years after my mother passed away, I travelled with my brother and sister back to Ghana. I say "back," but I had never been before. This quirk of speech is so common to first-generation Canadians. We say "return," and we mean "arrive"; we say "return," and we mean "origin." There is a tension between these two meanings: one rooted in the future, the other charting a past.

My siblings and I had long spoken of Ghana as the missing fragment, the answer to the sense of dislocation we had lived with from childhood. If we did not quite belong *here*, we felt, there was at least an *elsewhere* that might yet embrace us, fill us with the certainty of home. But nearly from the outset of our arrival in Accra, we felt strange and alienated, as if the plane had landed not in Africa but in another world entirely. We existed in a

state of wonder and anxiety, startling awake suddenly each night in the silent dark. We spent our days in the streets and markets, watching as if from a distance the bright crowds wandering the roadways. The city swelled with exhaust and debris. We were driven to my father's village in the south, the air from the window warm and smelling of flowers and garbage and metal heated by the sun. Some part of us, we recognized, was undeniably rooted in all we saw of the country. But the larger part of us belonged elsewhere, thousands of miles away, among the rituals and people and languages that had defined us from birth.

In the coming days we would visit my father's childhood home and spend time with his 101-year-old mother, understanding what it must have meant to be her son. We wandered the quiet streets of his boyhood town, took long walks to the shore. There seemed to be two distinct Ghanas: the country's surface — chaotic, modern — and its shadow story, the place of my father's remembering, all that the country had risen from. One was laid overtop the other, like double exposures. So many versions, so many phenomena, coexisting.

The expanding world, in that moment, felt like it was accelerating at a dizzying rate. Passing a food stall, I wanted to reach into the bins, as if this would ground me, fix me in reality. I felt dazed, nervous, and realized I had been steeling myself to make the long trip north to my mother's sisters. In all her living years I had never met any of her family, and the thought of that coming

encounter, which struck me as both a homecoming and a likely mistake, sent me into a soft panic. I had the urge to plunge my hands deep into the market's burlap-lined barrels, to feel the cool, hard pressure of dried grain in my fist, the certainty of its weight.

We arrived late in the afternoon, having had trouble finding the house, and when we stepped from the car, wiping at our damp brows, we half hoped they would not be home.

Almost at once they came out. And they were astonishing, these two women, one wearing the face of our dead mother and the other one of illness, though she was smiling, her eyes running with tears, her hands clasping and unclasping, shaking.

We hugged, the five of us, my aunt Felicia smelling faintly of cinnamon bark.

I can hardly recall the details of that first night, but I do remember one moment so vividly that to this day I grow emotional trying to describe it. The five of us had gathered on the front porch of my aunt Philomena's home, the darkness around creaking and hissing with nocturnal creatures. Drinking glasses of lukewarm coconut water, we sat in companionable silence, staring up at the night sky, Philomena singing softly under her breath. So much had changed for my mother across the years: she had married and borne children and become, in her last decades, a geriatric nurse. Her future had been made clearer, hurtling towards her at a frightening speed. So much of the external world had also been clarified, so

much about time and space. Robots had orbited and then been landed on Mars, capturing the first pictures of its surface, a rover crawling through its dead lake beds and rocky canyons. A balloon had been set afloat on Venus and sound recordings made of its atmosphere, silvery ghost songs. The shuttle *Challenger* blew up over clean American skies while her children and millions of others watched in shock from their quiet, bright classrooms. And each of these events, however sad or exhilarating or improbable, had brought my mother's life into sharper relief. They had driven her back into her youth, back to her thrilling and terrifying dreams for the future. Now we sat in the country she'd abandoned as a girl, listening to the singing of a voice almost identical to hers. Time fell away. I closed my eyes.

CHAPTER FIVE

ASIA AND THE ART OF STORYTELLING

1

I ARRIVED IN BEIJING on a warm spring afternoon, and I could not see the sun. The sky was a smooth brown veil, a pin of brightness dimly visible behind it. When I commented on this, my guide tilted his face to the haze, smiled. "Huh," he said. "I don't notice anymore."

Despite this, the light was grand and diffuse. Beijing is an illuminated city whose light feels ancient. My guide was a tall, sprightly American with expressive hands. He was wonderful company, with his quick turns of phrase and a voice always seemingly on the verge of laughter. Together we wandered through streets streaming with people, the markets bright with dresses, shoes, keychains, fruit, every desired thing, the night thrumming with the low, almost animal sounds of traffic. I had never been

so awake to a city, to its possibilities for surprise and danger. I remember one evening, as we walked a road fragrant with cherry trees in bud, being approached by a man muttering some offer. My guide answered in flawless Mandarin, and without explanation he gestured that we should follow the stranger. We passed through alleys smelling of mud, streetlight glinting off their puddles, the surrounding buildings looming dark on both sides of the narrow path. I insisted on knowing where we were going, when suddenly the stranger wrenched open a door. We descended a stairwell buzzing faintly with insects. We had entered a second, buried Beijing, stepping across broken tiles, ducking loose wires hanging from a torn-out ceiling. Swiftly and without speaking, the stranger opened another door. Bright light flooded our faces: it was a modern shop crawling with people, the shelves lined with pirated movies and books. The crowd milled about as if this were a normal store, at a normal hour, and not as it appeared: the dreamscape of a madman who understands how the common human desires can be driven underground and buried.

Just as memorable to me was an afternoon spent drifting through a market near Tiananmen Square. It struck me as the repository of even more far-flung desires, with its intricate steamed foods and metal gadgets, its iridescent beetles on whose backs were pasted fake gemstones, so that the insects glittered like brooches. People flooded by. I caught sight of a group of men all similarly dressed, as if in uniform. They were small in

stature, most appearing no taller than myself. Leaning over, my guide spoke in a voice meant to sound neutral, but that was tinged with bemusement: "A bus has obviously come in from the countryside."

As the men passed, we all of us looked openly at each other. There was nothing malevolent in our glances — they were looks of unfiltered interest, free of negative and positive charges.

I recall very clearly one man's lined, sun-baked face. I remember the faded grandeur of his clothes — his black suit tidy and pressed but threadbare. I pictured him laying out this suit the night before in anticipation of the journey, the prospect of the city's novelties tempered by the coming judgement of its people, city dwellers happy enough to eat the food harvested by his hands but who at a turn might treat him with the condescension betrayed by my guide. I recognized, too, a commonality between us: that of being unmoored in a city we neither of us inhabited, carrying in our bodies and our clothes the mark of the foreign. Our alikeness felt more potent than any difference.

But was this actually true? I think in my desire to find an ally in that moment, to feel understood and to understand, I had projected onto the stranger my own inner unease. Perhaps everything I sensed in him reflected my own prejudices, based on romantic and reductive ideas about city lives and country lives, and on my strong, sudden urge for complicity. Perhaps the man felt the opposite; perhaps he barely took note of me beyond my

passing form; perhaps he felt absolutely nothing at all. We form judgements as much from fabulist notions as from fact. Faced with what we share and what separates us, we decide in the moment to seek out the common or deny it, to succumb to a sense of familiarity or its opposite. We measure the gulf of experience between ourselves and another, and we decide how, if at all, we will allow it to matter.

The Polish journalist Ryszard Kapuściński, who spent his career chronicling human otherness, has suggested that when we meet a person in a foreign country, we are really meeting two people, though we may not always realize this. The first person is someone very much like us — he feels pain and pleasure, experiences successes and suffering, he shies from cold and hunger, is delighted in the face of sudden good fortune. He is as deeply rooted in his humanity as we are in ours. The second person, whose identity overlays the first, is more of a symbol — he has certain physical features informed by his genes, certain beliefs and convictions that reflect the culture in which he was raised. He presents as a kind of emissary of his race. When we meet a stranger, it is hard for us to separate these two entities. We are constantly negotiating his duality — the racialized person and the actual person — in a way that isn't fixed but shifts constantly, depending on the historical moment, our preconceived ideas, and even something as fleeting as our mood. In my isolation, I had looked upon the man from the countryside and seen someone

inhabiting the same unease and disillusionment I felt in the moment.

This double vision, and the outlandish illusions it can sometimes engender, cuts both ways. We experience strangers as "other," and are "othered" in return. The stories we tell ourselves about each other have about them the duality of Kapuściński's foreigner: they are about living, breathing people, but they are also fantasies that largely reflect back on ourselves, betraying our own assumptions, hopes, hatreds, fears. And in those cases where what we "know" of others has been learned second-hand, as when I came across that man from the countryside with my guide's words in mind, the narratives become even more open to distortions. In this way, every story of the other is a triumph or failure of our willingness to free people from their symbols, to allow them to live.

2

STORYTELLING IS AS OLD as humanity, and is one of the means by which we seek to define and understand ourselves. Some stories are "true" — or at least attempt to represent some settled version of a truth — and some are extravagant fictions, exaggerations meant to appeal to our feelings, picturesque falsehoods we use to diminish or reinforce difference. The meaning of stories resides in their ability to establish that life is less random than it can seem. Stories locate people within places, and

affix histories — we know what he, she, or they were like because they existed there and at that time. Roles are clarified; reasons are given for why things should be the way they are. Stories can be illuminating; but they can also be cages, forcing people into roles and histories into verdicts that bear little relation to the truth.

Looking at the ancient relationship between Asia and Africa, it struck me that storytelling — and all its complications — might be an interesting lens through which to consider those encounters; specifically those in which China and Japan made connections with the countries of East, West, and Central Africa. For centuries, Asia and Africa had no contact at all, so each had to rely at times on the testimony of foreigners to form their collective story of the other. Because, for example, both China and Japan lacked strong expansionism into pre-twentieth-century Africa, their ideas of Blackness were sometimes informed by imported stories, by the narratives of Arab traders from Africa, or by Westerners. In seventeenth-century Japan, for instance, Dutch traders brought with them not only sugar, cotton, and deer pelts, but also negative sentiments about the dark-skinned people they traded as slaves. This is not to say, however, that racism was something like a good of trade, delivered whole-sale by foreign powers and mindlessly adopted by the locals. But in the absence of actual contact with Africans, these sentiments couldn't help but inform local ideas of Blackness. What happens when the stories arrive on the land before the people do? I was struck by the corrupting

influence of imported narratives, and also by how those stories were used to prop up local hierarchies already in existence.

When Asians and Africans did eventually interact, the verdicts each formed were wide-ranging, ever shifting, diverse — touched by curiosity, scorn, praise, envy, disgust, adoration. Actual contact both shattered and shored up existing myths.

3

BLACK CONTACT WITH CHINA is generally thought to have begun with the Tang dynasty (618–907 AD), when a trade relationship was established with the city-states of East Africa. African merchants, diplomats, and students travelled sporadically to China, developing a tenuous connection. Also present in China was African slavery, but it was a marginal feature of Chinese society. As part of their maritime expansionism, Arab traders brought, along with their goods, African men and women for purchase. Though China had many indigenous slaves, the moneyed class often preferred African slaves; as with the Moors at court in eighteenth-century Europe, their exoticism provided another means to display one's wealth. African slaves were called "Kunlun," a word that originally referred to a fabled mountain range once thought to span Tibet and India. By the fourth century, the term had come to be applied to frontier tribes, Khmers, and eventually, in the eighth century,

to Africans. The number of African slaves in China is thought to have been relatively small. Despite this, in the greater cultural imagination, they were seen as low, frightening, dangerous beings.

Perceptions began to shift towards the latter centuries of the Tang dynasty. Though an air of unease remained, the long years of contact and integration, and increases in the number of slaves, began to complicate local attitudes. Alongside notions of ferocity and uncouthness came other narratives. Kunlun began to be romanticized in stories and books as a heroic people, loyal, resourceful, high-minded, even magical. They were also, in some cases, embraced as ethnically Chinese. These differing beliefs were very much drawn along class lines — only those with great wealth came into everyday contact with Kunlun, and the proximity weakened the more damaging myths. These positive perceptions continued with the transition to the Song dynasty (960–1279). Written accounts expressed admiration for the discipline and skills of Black seamen on Chinese ships. Ideas of Blackness would again shift swiftly, however, when increased numbers of slaves began arriving from the islands of the Comoros and Madagascar, their forebears having been taken there years earlier by Arab traders. The newcomers settled mostly in Canton province, and they were seen by the local populace as unassimilable: impossibly foreign and primitive.

The scholar John G. Russell suggests that these negative opinions, following as they did a dramatic increase

in the Arab trade, were likely informed by Persian and Arab traders in much the same way that the Japanese, centuries later, would acquire theirs from Europeans. The link between Blackness and slavery was a defining factor in how widespread racial discrimination became in the West. This discrimination was brought in its own form to China by the Arab and Muslim middlemen who traded there, and on whom the Chinese relied for information about a continent they had never seen. He notes that two Chinese words for Black people, "Ts'engchi" and "T'seng-po," come from the Arabic "Zinj," meaning "Negro." In this way, a story was bequeathed and a story inherited. And these second-hand verdicts, when paired with the lack of contact that gave rise to the local view of the Kunlun as unknowable and primitive, cemented Black people's status as the absolute "other."

Interestingly, despite the Kunlun's perceived inferiority, free Africans were seen quite differently. A striking example is the East African merchant Zhengjiani, whose arrival on Chinese shores in 1071 was met with celebration. He and his fellow merchants were reportedly treated with the deepest respect, received by Emperor Shenzong himself. Elaborate banquets were thrown in their honour, and they were showered with gifts. They were all granted ambassadorships, with the emperor bestowing on Zhengjiani the title of "Lord Guardian of Prosperity." His arrival, and his subsequent return in 1081, when he was presented with piles of white gold, solidified important diplomatic ties between the regions.

The bravery, intelligence, and honesty for which Zhengjiani and his fellow merchants were celebrated were obviously no more grounded in fact than the backwardness and depravity of the Kunlun. Like so many of our modern prejudices, all were beliefs of convenience. Trade with East Africa was incredibly profitable, and the shift in thinking was necessary for its survival. By the eleventh century, these economic ties were strengthened, with prized goods frequently arriving from Africa, goods like frankincense, for circulation; tortoise shell, to treat consumption; ivory, for buttons and buckles; rhinoceros horn, for aphrodisiacs; and even exotic animals such as ostriches, giraffes, and zebras. This trade expanded during the Yuan dynasty (1271–1368), so that by the time of the Ming dynasty (1368–1644), maritime commerce was well established between China and the city-states of Malindi (in modern-day Kenya), Kilwa (in modern-day Tanzania), and Mogadishu (in modern-day Somalia).

The rise of European trade and expansionism in the mid-fifteenth century eventually cooled the trading relationship between the East African states and China. Though not ended outright, African-Chinese relations lessened considerably as each continent reoriented its gaze towards Europe.

4

HALFWAY THROUGH MY TRIP to China, I set out into the countryside to see the Great Wall. The temperature had

dropped overnight, and as I was driven higher into the hills, the fields became pale with snow. At the entrance, I ascended the winding path through endless vendors selling their wares, men and women calling out for me to buy their jade paperweights, golden coasters, colourful wood-buttoned jackets. I made my way up to the cable cars. Climbing inside the swaying hold, I was lifted into a frost-whitened sky to cross a canyon of dark trees, finally reaching the Wall. The air tasted faintly of metal, the wind growing colder, prickling my cheeks. I walked in one direction, letting myself be led by the bends of the path. For hours I passed through the great fortifications, the stone by turns dark and light, its curves stretching into the distant fog. Snow began to fall.

This struck me as the perfect time to leave. Retracing my steps back to the glass cable car that had first brought me to the Wall, I realized it was nowhere to be found. I tried another exit and discovered that this, too, was a dead end. It dawned on me, suddenly: I was lost.

How does one get lost on the Great Wall of China? One would think that on a wall, there is only a forwards and a backwards. I have a famously poor sense of direction, but to be this confused, it seemed as if there had to be some dark magic at work.

I searched for the entrance, for the cable cars that had lifted me so breathtakingly above the ocean of trees, but they seemed to have dissolved. There was, strangely, no one else around — it was apparently an unpopular day to visit. The snow began to clot on my eyelashes, so that I

had to blink very deliberately. I tried to stifle the help-lessness I felt when each new exit led nowhere.

And then, as if by some miracle, two dark-haired women appeared suddenly at a fork in the path. It was as if they had been summoned by my desperation. Astonished, I began to gesture that I was lost. They smiled and, speaking in that beautiful language as opaque to me as the snow, one of them brushed flakes of ice from my hair as the other turned and drew from some hidden canister a Styrofoam cup steaming with tea. Where she had gotten this, how she had managed to keep the water hot on so cold a day high up in these hills, I did not know. Only that she seemed in that moment to know exactly what I needed, and that together with her friend they seemed spectral, two ghosts. The unexpectedness of this, the strangeness of it, touched me.

And yet, even to them, I could not make myself understood. They peered at me, speaking softly, blink-ing at my questions. Finally, they gestured for me to move on. I began to walk from them, the tea steaming in my fist as I wandered some distance. When the snow began to thicken, sticking to my hair and my coat, I grew panicked and turned to go back to them. But now it was the women I could not find — it was as if I'd imagined them. The driving snow had erased but the dimmest traces of footprints. Only the heavy white air remained, blanketing the vista.

I was lost as I had never before been lost — absurdly, in a contained space, alone in the cold, with no common

tongue to help me. The light began to dim. I thought of
evening back in Beijing, the smells of grilled food drift-
ing into the street from the restaurants, the lit buildings
filled with warmth and people, and I longed to return
there. In the gathering darkness, I sought an exit, looking
for a familiar path out. But I could not find one.

5

IN 1579, A BOAT ARRIVED at the port of Kuchinotsu, in
Nagasaki, on the southern island of Kyushu. Aboard was
a group of missionaries from Europe. After disembark-
ing, they made their way to the capital, Kyoto. Among
them was one of the most powerful Jesuits of his day,
Alessandro Valignano, who had spent the past six years
travelling from his native Rome to the countries of
Portugal, India, Mozambique, Malaya, and Macau on his
way to the missions of the Indies. He hoped to convert
thousands of Japanese to Christianity. Alongside him,
acting as his valet and his bodyguard, was a figure the
like of which had never been seen on Japanese soil. A
dark-skinned man, towering, so thick-boned and heavy-
set he had the immovable air of a maple. As rumours of
his presence spread throughout the city, people began
to gather in the streets. An eyewitness account by the
Portuguese Jesuit Luís Fróis tells of the townspeople
clustering in small crowds, apparently eager to glimpse
for themselves this unusual arrival. Making their way
through the streets, they took on the dimensions of a

riot, jostling each other, fighting for space. More and more joined, and they eventually found their way to the residence of a Jesuit. The crowd broke down the doors and rushed in, stepping and climbing on top of each other in their eagerness to see. Many were injured, with some crushed to death.

Learning of the incident, the feudal ruler Oda Nobunaga ordered that the unusual man be brought to him. By all accounts, Nobunaga could hardly believe this apparition was a man. At the time, the average height of a Japanese man was five feet two inches; this arrival, called Yasuke, stood at least one foot taller, thickly built, with skin described by one Jesuit as "black as a bull" and by another as "black as ink." In fact, Nobunaga believed that it *was* ink — he ordered Yasuke stripped to the waist and bathed. When this yielded nothing, Nobunaga tried to rub the pigment from his visitor's skin with his own fingers — a sequence of events that remains closed to us from Yasuke's point of view but that is obviously freighted with objectification. No doubt such objectification was familiar and even unremarkable to Yasuke, given the contours of his life — he had lived so long as a repository of others' romantic notions it likely didn't register as anything offensive. And that is maybe one of the most maddening things about the histories of such encounters: that we know so little about the African reactions. This is due to a lack of written accounts from Black perspectives. But it leaves us with a half-shuttered view.

Nobunaga had believed that Yasuke must either be

a guardian demon or a god; he was black as only temple statues were black. But touching Yasuke, hearing him speak his rich, inimitable foreigner's Japanese, Nobunaga realized he was only a man. He threw a feast in Yasuke's honour, made him gifts of money, and requested that Yasuke train to become a samurai — an honour never before bestowed upon any foreigner. It would elevate him into Japan's warrior class, the top echelon of society. Yasuke accepted and was granted a house, a stipend, and even, in a turn that may have felt uncomfortable to him, his own manservant.

That Yasuke had arrived fluent in Japanese was a great asset — Valignano likely had him learn it on the voyage over; he had always insisted his missionaries be as versed as possible in local culture. It is also assumed that Yasuke already possessed skills as a warrior, as he is believed to have become a samurai after only one year, a remarkably short period of time. Samurai usually trained from boyhood. Nobunaga granted Yasuke the role of sword bearer in the royal guard, for he felt Yasuke had the "might as that of ten men." This was an era in which Japan was still suffering the aftershocks of a civil war in which hundreds of petty warlords had vied for control of the country. Peace was only restored when the three remaining feudal lords came to a cautious truce. Nobunaga was the most powerful of them, ruling over the capital, Kyoto, as well as the centre of the country. But the balance of peace was precarious, and very frequently his kingdom and all that he owned were the

targets of espionage, ninja attacks, and the assassinations of those who pledged him fealty. Rogue bands of radical, armed monks, minor warlords, and bandits all threatened his rule.

By all accounts, the relationship between Nobunaga and Yasuke grew extremely close. Nobunaga was a renowned eccentric who wore Western dress and relished the company of highly disciplined and intelligent men. He apparently delighted in Yasuke's conversation, the tales of his travels through Africa and India, where the historian Thomas Lockley believes Yasuke spent time before his arrival in Japan. Yasuke would have made for more lively company than the missionaries with their religious agendas, and his practice of martial arts would have also been a special point of connection. Beyond this, Nobunaga was an arts lover who adored the theatre of Noh; Yasuke, for his part, performed a historic form of Swahili narrative poetry that extolled heroic deeds.

Yasuke's knowledge of Swahili is often seen as a clue to his possible cultural identity. Some historians have concluded that Yasuke must have come from Mozambique, as Swahili is still spoken in the northern regions. During this era, the Yao Peoples had just experienced their first contacts with the Portuguese. This theory might also explain how he came to be called Yasuke — the common kanji male suffix "suke" added to the tribal name. Others have countered this by suggesting he may have come from Ethiopia (and his name derived from Yisake) or Nigeria; still others

believe he was from the Dinka tribe of South Sudan. Lockley, in his biography of Yasuke, assumes that he was abducted as a boy by Indian or Arab slave traders and trafficked through the Middle East and across the Indian Ocean. During this era, thousands were transported from Northern Africa to India or the Arab world every year, as slaves, yes, but also as mercenaries. Indian rulers particularly favoured African warriors as part of their royal guard. Lockley believes that Yasuke had been a child soldier in Goa and Gujarat in India, before crossing paths with the Jesuit missionaries who recognized his skills and hired him as a valet.

Yasuke and Nobunaga would eventually suffer defeat by a rival faction, forcing Nobunaga to preserve his honour by committing hara-kiri, ritual suicide by disembowelment. The warlord's final wish was for Yasuke to carry his head and his sword to his son.

With Nobunago's death, Yasuke became a ronin, a samurai without a master. His own life had been spared. Their enemy had believed Yasuke otherworldly — not quite beast, not quite man — and so he let him go.

WHAT ARE WE TO MAKE OF Yasuke's story? He appears in the historical record only between the years of 1579 and 1582. Both the day of his birth and the day of his death are unknown. Our glimpse of him is so fleeting. Perhaps the problem of Yasuke is that he has always been forced to mean something. For Valignano, Yasuke's

physical and intellectual gifts were another way the great Jesuit could shore up and make visual his own power. Nobunaga occupied a murkier realm: he, like Valignano, began with the fiction, but he allowed himself to look beyond Yasuke's surfaces, seeing beneath to a being of blood and bone, something nearing a man. We know the two became friends, but did Yasuke feel free to reveal his deeper self? What were the things he'd had to abandon in his voyages far from home, and in fact, where *was* home to him? Did he remember his family, his friends, the texture of a life whose details might now feel lost to him? What, in the end, did he mean to himself? We look to him now as a forgotten figure, and ask him to tell us something about the lives of people like him. But perhaps he himself could find no meaning. Maybe he felt only the fact of life's randomness, its push and pull, the way the will of others had twisted things and dragged him into worlds he could never have imagined. The pain this had caused him, but also the wonder of it. And perhaps, in those few moments to himself, when he laid down his leather-and-metal armour, freed from the needs of others, his relief at the opportunity to set aside heroics, to let himself be weak.

6

THOUGH SOME HISTORIANS speculate that Africans may have first arrived in Japan through trade with China as early as the tenth century, it is generally believed that

first contact didn't occur until the sixteenth century. Unlike China, Japan had had no direct trade with Africa itself, and it hadn't trafficked in African slaves. Starting in the 1540s, nearly forty years before Yasuke's appearance, a sizable number of Black Africans began arriving in Japan on the sailing vessels of Dutch and Portuguese traders. They worked as servants and crewmen, and some were, or had been, slaves. As with Yasuke, their appearance was met with awe. In 1547, the Portuguese captain Jorge Álvares described the locals' first reactions: "they will come fifteen leagues just to see them and entertain them for three or four days." Until the arrival of Africans and Europeans, Japan had ostensibly been a homogeneous society — though then, as now, this is not entirely accurate. Alongside ethnic Japanese lived East Indians, Malays, Southeast Asians, Koreans, Chinese, and Indonesians. Among Japan's own ethnic minorities were the Ryukyuans, and the Ainu Peoples to the north. Despite this, Japan had generally gone about classifying people into one of three civilizations, or *sankoku*: Japan, India, and China, which was conflated with Korea and other states that used the Sinocentric system of international relations, in which China is viewed as the centre. Anyone outside of this scheme fell into the category of *yabanjin*, or barbarian. The sudden African presence spurred national conversations about race.

Because of their skin colour, Blacks were initially linked to India, the sacred homeland of Buddha. And yet the condescension and cruelty with which Europeans

treated their African slaves clarified Blacks' status as a people deserving of contempt. When, during the Edo period (1603–1868), Japanese intelligentsia stirred up public ill will towards Buddhism and India, those with darker skin were persecuted. Some scholars, however, argued for a more modern view of humanity, rooted in what the races share, in what is familiar, the common story. So it was that Blackness in Japan became a conflicted thing, by turns tolerated and despised, admired and feared.

The number of Africans living in sixteenth-century Japan has been estimated at several hundred. While some arrived as slaves, others were sailors, servants, valets, translators, and soldiers. They worked not just for Europeans but, like Yasuke, for local feudal lords as sword bearers, gunners, court entertainers, and drummers. A small number established lives for themselves in Deshima, a Dutch settlement, and despite a nationwide isolationist policy that made venturing abroad difficult, they not only socialized freely with the local population but were given occasional permission to travel.

Sometimes the brutality meted out by the Europeans roused local sympathies. In his physician's diary, Hirokawa Kai lamented the treatment of these "men of fine character," who "perform backbreaking and dangerous tasks for their masters without complaint [and] . . . work hard, climbing the masts of ships without the slightest display of fear." He was disgusted by the Dutchmen, who whipped slaves "as if they were beasts and who kill

the young and strong who resist and throw their bodies into the sea." He wrote of the lack of medical treatment for Blacks who fell ill, and how, when they grew too sick, they were poisoned (or as another eyewitness wrote, beaten to death). By many accounts, the Dutch behaved hatefully towards the Japanese as well, treating them with scorn and derision.

And yet, with the deepening of the Dutch presence came the dissemination of a Dutch education (Rangaku), which brought Western knowledge of the sciences but also Western theories of race. The story of Africa was a story of savagery, a story of cannibals worshipping no gods. With the introduction of Darwinist ideas in the early Meiji period (1868–1912), and the publication of several editions of Darwin's *Descent of Man,* the traditional Japanese Sinocentric classifications gave way to Westernized ideas of race.

The vagaries of the slavery taking place on Japanese soil also changed ideas about Blackness. Africans were not the only ones sold into slavery; Europeans had also bought and used Japanese slaves until the practice was outlawed in the late sixteenth century. Because of this ban on Japanese slaves, Europeans began to import more African ones. Before this, it had been possible to meet Black people who held positions other than slaves. After the ban, the only Blacks to arrive on Japanese shores were slaves, and their numbers increased. In 1639, interactions between the Black population and the locals were also banned. Prior to this, when Europeans had given

wildly exaggerated accounts of the depravity of Africans, the Japanese could judge for themselves the truth of it. Now this became difficult to do. There was little chance to change the story.

This is not to say that Japanese ideas of racial difference were wholly imported from the West. Japan had its own hierarchies, systems in which its indigenous ethnic minorities, peoples such as the Ryukyuans and the Ainu, were viewed through a lens of "otherness." But some Japanese intellectuals did use Western racial ideologies to bolster their own agendas, whether to prop up Japanese nationalism or to dismantle their own religious hierarchies. For example, scholars seeking to advance the cause of Shintoism used Darwinist ideas to attack Buddhism and Christianity. Also, social Darwinism — the theory that human beings were subject to the same natural laws of selection as animals and plants — gave a murky if convenient scientific basis for already existing Japanese systems of rank.

Interestingly, ideas of Western superiority informed not only Japanese ideas of the "other" but also how the Japanese came to see themselves. Before the long years of contact, anti-white sentiment had been a common feature of Japanese society. During the first, tentative years of trade between Japan and Europe, the Japanese had derided Europeans as uncivilized and even demonic. Gradually, with prolonged cultural exposure, the story changed and whiteness became its opposite: the height of civilization, prowess, and beauty. Some public

intellectuals of the day — figures such as Takahashi
Yoshio and Kato Hiroyuki — even argued for intermar-
riage with Europeans to "improve the Japanese race." The
scholar Mori Arinori made the case for national adoption
of more "progressive" and "logical" European languages.
This shift was not so much rooted in an innate sense of
racial difference as it was in the understanding of how
race was attached to status, and of how those hierarchies
had been shaped by the fact of Western power. Japan
erected its own stratification, one rooted in traditional
structures that already existed. Native Americans and
African slaves were sometimes equated with *eta/hinin*,
outcasts, and *senmin*, low people, which showed how
racial prejudice was shaped not so much by actual skin
colour but by the low social rank these groups occupied.

The author Isabel Wilkerson makes an illuminating
distinction between race and caste. Race is the genetic
inheritance that gives us certain hair textures, certain
shades of skin. Caste is the way we use those physical
differences to rank each other, the social codes we uncon-
sciously adopt to uphold the established social order. It
pits the ostensible superiority of one group against the
ostensible inferiority of another group, based on physical
traits that would otherwise be neutral but are instead
taken as evidence of innate supremacy or baseness.

And so, while race is ostensibly a set of physical char-
acteristics, caste is the damaging fiction we tell about
those bodily differences. In Japan, that fiction arrived
early, before the people at the heart of the story could

give nuance to the narrative. And yet, even against those obstacles, in the wake of actual contact, the stories were able to change and evolve, even occasionally touching upon something like the truth. But the war against caste — which is essentially the war against false stories — was never fully won, and its effects reverberated on both continents.

7

EARLY IN THE FIFTEENTH century, the admiral Zheng He sailed an immense armada from China into the open world. He was in his day one of the greatest maritime commanders to touch water, yet his rise was unlikely. He had been born into a Chinese Muslim family and at a tender age was taken prisoner by the Ming army for refusing to disclose the location of an enemy. In keeping with military customs, he was castrated, a punishment that usually ended in death. Miraculously, Zheng He survived, and in his youth he grew to a formidable height — he was fabled to be seven feet — and showed all the characteristics of a born leader. When a powerful prince, Zhu Di, sought a houseboy, Zheng He was a natural choice.

As with Nobunaga and Yasuke, ruler and disciple grew extremely close. Together they plotted to overthrow the emperor of China. Their coup was a triumph, with Zhu Di becoming the new emperor. Among his first appointments was to give Zheng He the command

of an enormous fleet. He was to sail the world in a show of cultural and military power.

Zheng He made seven large-scale expeditions during the years 1405 to 1433. His was easily the greatest navy in the world. He had a force of over twenty-eight thousand men, who included among their numbers 5 astrologers to forecast the weather, 7 grand eunuchs, 180 doctors, legions of herbalists, mechanics, interpreters, geomancers, carpenters, cooks, accountants, blacksmiths, tailors, sail makers, and astronomers to make a full study of the heavens.

Zheng He had some three hundred ships, several as long as four hundred feet. The writer Nicholas D. Kristof puts this in perspective by noting that on his 1492 voyage, Christopher Columbus had ninety sailors on three ships, the longest of which stretched eighty-five feet. All of the ships of Columbus and da Gama combined could have been stored on a single deck of a single one of Zheng He's ships. The crown jewels of his fleet were his so-called "treasure ships," of which there were sixty-two. One hundred and seventy feet wide and four hundred feet long, they thrummed with nine red silk sails, their cabins luxurious and their main decks measuring fifty thousand square feet. They had a displacement of at least three thousand tons. The holds contained warships and patrol boats and tankers carrying fresh water. There were also live horses; one can imagine their ghostly sounds across the open water, the thudding of hooves, their plaintive sighs.

For the next five centuries, Zheng He's navy remained the largest ever built. Only at the outset of the First World War did the West amass anything comparable. He reached the coast of East Africa half a century before Columbus set sail. There he established his country's first trade with the continent, bringing back to China ivory, spices, medicine, hard and soft woods, and even live giraffes. Crowds would gather in the Chinese ports to watch the miraculous animals descend the docks. Many believed they were *qilin*, the mythical Chinese unicorn.

Zheng He's naval reign was not to last. After the death of his benefactor, a power struggle broke out, and the Confucians won. They despised the eunuchs, whose promotion of commerce and progressive ideals they viewed as immoral. One of the Confucians' first measures was to end the era of expansionism. With the new emperor's approval, they banned the building of new ocean-bound ships and the sailing of existing ones, eventually ordering them dismantled. So that no man would again be tempted to raise a fleet on the sea, they destroyed Zheng He's records.

In researching the story of Zheng He, Kristof discovered that one of Zheng He's ships had crashed on the tiny African island of Pate and permanently stranded a group of Chinese sailors, whose descendants live there to this day.

Pate is just off the coast of Kenya. Kristof describes it as a place of lush, shadowed groves, sprawling jungles

and black sand beaches. Its forests were thick with fruit trees and palms whose fronds gave stone houses cover from the sun. The island had few roads, no electricity or cars, and it was reachable from the mainland by sailing through constricted waters only passable at high tide. Kristof was astonished to discover in the faces of its people evidence of what he had until then only supposed might be true. The villagers were much fairer-skinned than the mainlanders; their hair was only very loosely curled; their eyes hinted at Asian ancestry. A village patriarch, Bwana Mkuu Al-Bauri, whose grandfather was the "keeper of history," explained: "Many, many years ago, there was a ship from China that wrecked on the rocks off the coast near here. The sailors swam ashore near the village of Shanga — my ancestors were there and saw it themselves. The Chinese were visitors, so we helped those Chinese men and gave them food and shelter, and then they married our women. Although they do not live in this village, I believe their descendants still can be found somewhere else on this island."

Peoples from various Pate clans corroborated this story. The name of one of the island's oldest, now-destroyed villages, Shanga, was said to be derived from the name "Shanghai." Most illuminating were the stories some told about the actual shipwreck. The most remarkable goods to change hands between local African kings and Chinese sailors were the giraffes. The locals talked about their ancestors watching the Chinese load them onto their ships, and how very shortly after setting out,

some ships struck rock off the island's eastern coast. The sailors abandoned the animals to their fate and swam ashore, carrying armloads of whatever could be salvaged. This would have been a late expedition, clearly, as the sailors were never rescued by a new fleet.

The journalist Frank Viviano, who visited Pate in 2005, notes that ceramic fragments discovered there were authenticated by the local history museum as Chinese in origin, most likely from Zheng He's journey to the Swahili coast. Chinese ceramics are common in certain parts of East Africa; while their presence in Pate might be due to Arab traders, it's also possible that they were inherited, given that it is overwhelmingly one clan, the Famao, who owns them. The islanders also play drums in the Chinese style, and practise a kind of basket-weaving native to the southern regions of China. In a 1569 account by the Portuguese priest Francisco de Monclaro, he describes an advanced silk-making industry on the island when such a thing would have been virtually unknown in the region. Several elders corroborated this in 1999, telling Kristof their artisans had produced silk until just half a century earlier. Most interestingly, Viviano was shown a grave-yard said to hold the remains of Chinese sailors; the graves were constructed of island corals and appeared nothing like mainland burial grounds, their half-moon domes and terraced entryways mimicking the tombs of the Ming dynasty.

It is telling how both sides have gone about negotiating

this story. In Pate, it seems accepted and settled, writ in the skin of its people. In China, the narrative proves more tentative. As there are no Chinese accounts of an African shipwreck (which would seem a natural consequence of Zheng He's records being destroyed), the story exists in the realm of half myth, despite some present-day attempts to shed light on it (a recent article in the *China Daily* stands as one example). But the spectres it raises — particularly of miscegenation, still taboo in some communities — can be ignored in the absence of written evidence. The romantic stories of the sea voyages are celebrated; the human element remains murky.

8

AS I SIT IN MY LIVING ROOM, looking out at the sea, I can hear my children playing in our overgrown yard. They shriek and scold and cry out at each other. It is a Friday; they are usually at school, but a local power line has fallen, leaving their classrooms in darkness, so they have been finally sent home. Out in the fresh air, they delight in their sudden luck, laughing wildly even as they begin to argue.

And yet, as I read about an incident several decades ago in the Congo, the texture of their voices — joyful, oblivious — starts to overwhelm me. The contrast between the words on the page and their bright play is too much. After some moments, I gather my things and walk away.

In the 1970s, a demand for cobalt and copper led Japan to invest more heavily in the natural resources of Africa — specifically in the mineral-dense south-eastern region of Katanga province, in the Democratic Republic of the Congo (then called Zaire). To mine these resources, the Japanese sent their own countrymen, who were granted living quarters in all-male encampments. These men had left behind whole lives; they had left behind lovers, wives, children. I imagine their reactions to their new country to be as various as their personalities, but it's clear there was much loneliness. They had a strong desire to connect — with their fellow workers, with the outside world. And so, tentatively at first, and then with greater need, the miners struck up friendships with locals, contacts that allowed them to leave for a time the confines of their camp. Some of the miners began relationships with Congolese women; some abandoned the camp entirely to live with them. It was hardly a scandal, socially speaking; their integration was just another feature of local life. In the homes of their women, they became again lovers, husbands, fathers. They were again the guardians of children who bore their eyes and their temperaments and their manner of laughing, and they played with them as they had played with those shadow children left behind back home, children whose voices were getting harder to recall with the years.

Finally the miners had finished their work; it was time to return home. How to negotiate these second, African families? For some, it would be shameful to

avow them. At the heart of that fear, alongside the usual shame at betrayal, lay the genetic and moral stain of miscegenation. However uncomfortable it is to discuss, it must be said that even today, Black-Asian sexual relations occupy the realm of taboo. I have never known exactly why this is, assuming there is no central underlying narrative but rather an accumulation of fictions that has led to this. The story of miscegenation is the story of the blood's corruption, of damaging one's name and one's line through taint. More personally, and painfully, it is to give one's children the inheritance of caste, to grant them a lesser role in the narrative. This, at least, is how I assume some of the Katanga miners might have seen things. For others, I'm sure, abandoning their children was the worse shame. Some might have wanted to stay, some to take their African wives and children back to Japan. Whatever their desires, the mining company forced them to leave, unaccompanied by any new family ties.

And here is where the stories diverge, become, on the one hand, a matter of public record, and on the other, the anguish of private lives. For according to local testimonies, the children and infants were murdered.

In Arnaud Zajtman and Marlène Rabaud's investigative account, the Katangan women take the reporters to a burial ground they say contains the remains of their bi-racial Japanese children. All reported similar stories of having brought their infants or very young children to the local hospital for simple check-ups or minor

illnesses. The hospital was run by the mining company. The mothers describe the single Japanese doctor with his stern female assistant, and how the two would only agree to treat the child if the mother was sent from the room. Almost without fail, the children would be carried home weakened and lethargic, and within hours they would lose consciousness and die. Naomie Mukombi, a local nurse who used to work at the mine hospital, confirmed to the journalists that the doctor and his assistant were vehement about being alone in the room with the children; she herself was never allowed in. The locals concluded what must have in the moment seemed unimaginable: to spare the miners shame, the doctors were poisoning their children to death.

If true, it is impossible to know how complicit some of the fathers might have been in this. Were some so rattled by the story of miscegenation that they condoned murder? It is difficult to imagine. Surely had some known exactly what was happening they would have protested; it seems unlikely that not a single man stood up.

In the wake of these deaths, mothers began to give birth at home, refusing to register their newborns. Young children were taken from the cities and raised in the countryside. Zajtman and Rabaud interview a woman called Nhanha Kamisawa, her heritage unmistakable in both her face and her name, who'd grown up in hiding. Her maternal grandfather believed she would be killed if she stayed in the city, and so she was spirited away, to spend her childhood toughing it out in the bush. There

is allegedly a whole generation marked by this violence, though the number of survivors is unknown because of the nature of the crime. A group of some fifty are seeking a formal investigation into the persecution and infanticides, and have together formed an association as a means of support and to engage in an organized way with legal counsel. Their plight is made harder by the fact that many were not born in hospitals and therefore have no documentation. They have submitted requests for official inquiries to both the Japanese and Congolese governments, but their pleas have so far gone unanswered.

9

OF ALL OF THE PLACES I failed to see in China, the one I most regret missing is the district of "Little Africa," in Guangzhou. Guangzhou is a two-thousand-year-old port city nestled on the banks of the Pearl River, one of the country's great southern metropolises, home to migrants from many nations. In the 1990s, thousands of men arrived from West Africa in the spirit of trade that for centuries has connected these continents. Most came from Nigeria, but there were also Malians, Congolese, Senegalese, Ghanaians. Taking up residence for several months at a time, they would scan the markets, shops, and factories, buying up goods at cutthroat rates to take back and sell in their home countries. This recalled to me one of my own experiences, in a cloth fair just outside

of Kumasi, in Ghana. I was on the hunt for an authentic Kente cloth — the traditional textile worn by Ashanti kings for millennia, characterized by its bright, colourful weave. I had lost the one I'd been given in childhood, and wanted to replace it. Searching table after table piled high with stacks of cloth dyed hallucinogenic colours, I finally gave up. Not one had been locally woven; all had been imported from China.

During its peak years, between 2005 and 2012, Guangzhou was home to the largest community of African expatriates in all of Asia, with an estimated one hundred thousand Africans settling there. But they remained a disquieting presence, too visible. In the humid summer days of 2009, two Nigerians fleeing the immigration police hurled themselves off a balcony, falling several storeys and badly wounding themselves (though they reportedly survived). Rumours of their deaths sparked demonstrations that exploded into riots when police turned brutal. Three summers later, an African man died in custody after being taken to the police station following a dispute over cab fare, leading to more demonstrations among the Black community. This provoked mass immigration sweeps and the closing of African shops and African churches. The provincial authorities began offering rewards to Chinese citizens who turned in Africans overstaying their visas, and in 2011 even made it temporarily illegal for hotels and educational institutions to offer Africans service. In 2014, the government began a process of gentrification

in "Little Africa," shutting down food stalls and intensifying police presence in the streets. Warehouses had mandatory CCTV cameras placed inside.

It was apparent the Africans were no longer welcome. As with any trade relationship, it was not just material goods that came into the country. The Africans brought with them ideas and values, too. Some founded secret churches in their homes. In a country in which non-state-sanctioned religion is frowned upon, it has long been illegal for foreigners to practise missionary work. Several of the newcomers were Muslim. Officials raided mosques and forced restaurants to remove Arabic from their menus.

The COVID-19 epidemic has only worsened existing tensions. After a handful of Nigerians tested positive for the virus in April 2020, Guangzhou authorities subjected African populations to prolonged quarantines and punitive routines of forced testing. Amid this hysteria, Chinese-owned businesses began refusing to serve anyone with dark skin. Signs appeared in windows prohibiting Blacks entry to restaurants. McDonald's was forced to issue a public apology for a laminated notice placed in the window of one of its Guangzhou restaurants. The sign read, in part, "We've been informed that from now on black people are not allowed to enter the restaurant. For the sake of your health consciously notify the local police for medical isolation."

Race itself was made a vector of contagion. In this spirit, African renters were evicted from their homes.

Hotels ejected guests without warning. Notably, mixed-race children and their African parents were reportedly granted greater protections; their adjacency to "native" Chinese gave them a bit of a shield. The Public Security Bureau, which would normally enforce visa terms quite strongly, has by some accounts been, during this pandemic, more tolerant towards those with Chinese family ties.

Meanwhile, across the Pacific, North Americans of Asian descent have also been attacked. Race, it seems, has become the fiction into which we pour our pent-up frustration and rage. Benign physical differences become, in the absence of understanding, stand-ins for an enemy virus we cannot visibly see. People are reduced to the symbolism of their bodies, and those symbols fuel a preconceived narrative. That is one definition of racial prejudice, though of course its forms are many. One of its lasting effects is to create a deep sense of alienation from a culture a person might claim as their own but that others would shut them out from. The story of belonging is not theirs to inhabit.

For Zhengjiani, for Yasuke, estrangement was the door through which they must eventually pass. They were told repeatedly these were not their worlds. It did not matter what they felt. They were at times both super-human and subhuman, but never just men, walking a shared earth.

But for the sailors shipwrecked on Pate, for the survivors of Katanga, for the children of Guangzhou — was

their unbelonging any different? Their world was the only world, inherited or assumed, and there could be no return to an elsewhere. Home was an exile in which they must wear their difference always.

<div align="center">10</div>

ON THE DAY BEFORE I was to leave China, I travelled alone to the Dongcheng District to visit the Forbidden City. Climbing from the taxi, I was for a moment disoriented; I could find no way in despite the noise of the crowds inside. Every ornate facade seemed, then failed to be, an entrance. Finally I entered the light-struck void at the heart of a series of ancient wooden palaces and temples. They spanned almost one thousand intricate buildings, serving from the fifteenth century as the emperor's winter home but more so as an extension of his limitless power. I had the impression of diffuse light on stone, of red upturned roofs, of sprawling stone courtyards. The air smelled of exhaust and dead flowers. I wandered the crowds, the weak sun pleasant on my shoulders, and it was not long before I noticed other things.

I had arrived in China for a book festival in the off-season, so most of the other tourists now there were people from other parts of the country come to see the capital. It so happened that I was, to some, as much a spectacle as the glorious surroundings in which we found ourselves. When I passed people, some reacted with animation, as if

suddenly yanked to life. A young woman in an oversized bomber jacket laughed behind her hands, tugging on her boyfriend's sleeve so that he would turn and look at me. A group of teenagers also laughed, one of them calling out, "Hello, Miss Michael Jackson!" Sometime later, as I passed through the shadows of a long portico, my hand gripping the cool rail, I heard someone shriek, and glanced up to see a woman grimacing at me, sneering. She turned to her friend, whose contempt I could sense even in this dark place — the twist of her lips over her very white teeth. When I met her eyes, she began, under her breath, to make grunting noises, like a gorilla. It was clear that whatever identity I actually inhabited, whatever sense of myself I had — all were obliterated in the face of my visual symbols. My story was writ in my body, and as these women saw it, it was a story that had no place in their country.

This is the story of China I am expected to tell. The story of exclusion, racial assumptions and damning myths. And it is a true story, and one to be called out and condemned. But there are other stories.

Towards late afternoon, exhausted, I took a taxi to the bookstore where the night before I'd given a reading. I'd walked for hours, and I arrived terribly thirsty. I sat in the adjoining café, asking for a water while perusing the menu. The water came hot, in a white porcelain cup with a sliver of lemon on the side, and I sighed, remembering only then I should have asked the waitress for ice; more often than not, table water is served boiled.

I was barely aware of it, but the man at the next table

gestured to the waitress, speaking abruptly in Mandarin. Moments later, she re-emerged holding a glass of ice cubes, and with her thin, anxious fingers dropped them one by one into my steaming cup, where they hissed and clicked against each other.

Thanking her, I glanced at the man at the other table; he looked expectantly back. He had a thin, narrow-boned face, his skin pale and his eyes dark and somewhat stern. I noticed he held in his hands a copy of Justin Torres's *We the Animals*. By chance, I had the night before shared the stage with the author, and I told the man so, also thanking him for the ice. He was surprised at the coincidence, and excitedly praised the book and the festival, speaking of events he was sorry to have missed because of his long work hours. Something occurred to him then, and he paused. "Wait, are you hungry?" he asked.

Before I could answer, he said, "Don't order anything." He rose so swiftly his own drink pitched to one side before the glass righted itself. "Come. Come with me."

I hesitated — I was not about to follow some strange man through a foreign city I had no bearings in. He laughed, apologetic. He only meant to take me to the restaurant literally across the street. He and his wife were hosting a party in honour of their newborn daughter — in fact he had only come into the café to wait for it to start. The gathering was a chance for their closest friends to meet the baby. He would be honoured if I joined them.

This was the last thing I expected, and I was later told how rare it was for locals to invite foreigners into

their intimate circles, especially complete strangers. I was apprehensive, but it struck me as a serendipitous opportunity to know the lives of others. I agreed to go.

The restaurant was strung with red-and-gold lanterns, its air hot and close. It was crowded but for the table we walked towards, a long, elegant structure of black wood that seemed carved whole from a single trunk. At the table sat a man in a crisp navy suit; beside him was a thin, hassled-looking young woman. She held the hand of another thin, hassled-looking woman, this one older, so I supposed they must be mother and daughter. They were startled to see me, and with polite laughs, asked my new-found friend in Mandarin who I was. When he answered, they laughed again, lightly, but that was all — they wanted only to know my story, what my books were about, how long I'd been a mother.

Other guests turned up, and their reactions were similar. My foreignness was as much a window thrown open as it had sometimes been a shut door. The curiosity shown towards me was not badly meant. People seemed eager to hear about my world, and my place in it, and I wanted to know theirs. I was mainly taken for an American or an African, and the fact of my Canadianness prompted cries of surprise and puzzlement. Mine was not the story my skin colour had taught them to expect, and what started as an odd meeting became very quickly a desire to probe deeper, to see beyond the symbols. Who, their questions seemed to say, are you *really*? I was happy to talk about my life, my home, my

country. And in doing so, I was struck by how my fears about the way I might be treated had created their own damaging narratives. Before I'd left for China, many had told me of the prejudice I was sure to encounter. I'd arrived in the country in full emotional armour, and I sought offence everywhere. Sometimes I found it. But sometimes my expectations of mistreatment did not give people a chance, and I plowed on, despite evidence of actual bigotry. So many people of colour who travel abroad will recognize this pre-emptive reaction against pain, an often justified one. But in my case, I realized that in its own way it had become a prejudice, a rushed verdict against strangers whose true thoughts and character had yet to be revealed.

Finally, the man's wife arrived, dressed elegantly all in white despite the danger this posed with a newborn, who remained a faceless bundle in her arms. She was at first puzzled to see me, but knew enough of her husband's whims to just shrug. She sat beside me and we talked about motherhood, as she smiled tiredly in the universal way of exhausted new mothers everywhere.

Suddenly her husband cried out, "Let Esi hold the baby!"

I thought she would object, make some excuse — I know the possessive instinct with newborns. But she only sighed and gestured for me to open my arms.

It seemed hours I held that child, staring into her small, frowning face, her tongue poking gently from between her lips, her smell a combination of sweet milk

and paper made hot from passing through a printer. A new, vaguely chemical, very human smell. Her eyes were the grey that saltwater can sometimes be, and they were empty of all expectation. Her world was still to come.

BIBLIOGRAPHY

EUROPE AND THE ART OF SEEING

Bindman, David, & Gates Jr., Henry Louis, ed. *The Image of the Black in Western Art*, Volume 1, *From the Pharaohs to the Fall of the Roman Empire*. Cambridge: Harvard University Press, 2010.

Bindman, David, & Gates Jr., Henry Louis, ed. *The Image of the Black in Western Art*, Volume 2, Part 1, *From the Early Christian Era to the "Age of Discovery": From the Demonic Threat to the Incarnation of Sainthood*. Cambridge: Harvard University Press, 2010.

Bindman, David, & Gates Jr., Henry Louis, ed. *The Image of the Black in Western Art*, Volume 3, Part 1, *From the "Age of Discovery" to the Age of Abolition: Artists of the Renaissance and Baroque*. Cambridge: Harvard University Press, 2010.

Childs, Adrienne L., & Libby, Susan H. *The Black Figure in the European Imaginary*. London: Giles, 2017.

Cotter, Holland. "A Spectrum From Slaves to Saints." *New York Times*. 8 November 2012. https://www.nytimes.

com/2012/11/09/arts/design/african-presence-in-renaissance-europe-at-walters-museum.html

Cunningham, Vinson. "Kehinde Wiley on Painting Masculinity and Blackness, from President Obama to the People of Ferguson." *New Yorker.* 22 October 2018.

David, Jacques-Louis. *Napoleon Crossing the Alps at the Saint Bernard Pass.* Painting. http://www.jacqueslouisdavid.net/napoleon-crossing-the-alps-at-the-st-bernard-pass/

Hooper, John. "A Spotlight on Black Figures in Old Master Paintings." *Wall Street Journal.* 5 August 2020. https://www.wsj.com/articles/a-spotlight-on-black-figures-in-old-master-paintings-11596625206

Jeffries, Stuart. "Dido Belle: the artworld enigma who inspired a movie." *The Guardian.* 27 May 2014. https://www.theguardian.com/artanddesign/2014/may/27/dido-belle-enigmatic-painting-that-inspired-a-movie

Laneri, Raquel. "Uproar over artist's painting of God as a black woman." *New York Post.* 30 May 2017. https://nypost.com/2017/05/30/uproar-over-artists-painting-of-god-as-a-black-woman/

Read, Erin Elizabeth. "Angelo Soliman Then and Now: A Historical and Psychoanalytical Interpretation of Soliman Depictions in Modern German Literature." Master's thesis, University of Tennessee Knoxville, 2006.

Said, Edward. *Orientalism.* New York: Pantheon Books, 1978.

Solomon, Deborah. "Kehinde Wiley Puts a Classical Spin on His Contemporary Subjects." *New York Times.* 28

January 2015. https://www.nytimes.com/2015/02/01/arts/design/kehinde-wiley-puts-a-classical-spin-on-his-contemporary-subjects.html

Spillane, Margaret. "The Democratic Paintbrush of Lucian Freud." *The Nation*. 1 August 2011. https://www.thenation.com/article/archive/democratic-paintbrush-lucian-freud/

Wigger, Iris, & Hadley, Spencer. "Angelo Soliman: desecrated bodies and the spectre of Enlightenment racism." *Race & Class*. Volume 62, Issue 20. 3 August 2020. https://journals.sagepub.com/doi/full/10.1177/0306396820942470

CANADA AND THE ART OF GHOSTS

Bessière, Arnaud. "Population: Slavery." Virtual Museum of New France, Canadian Museum of History. https://www.historymuseum.ca/virtual-museum-of-new-france/population/slavery/

Brown, DeNeen L. "A Whitewashing of History." *Washington Post*. 17 February 2002. https://www.washingtonpost.com/archive/politics/2002/02/17/a-whitewashing-of-history/b013fd77-9bde-4588-934e-345d1550bcda/

Cooper, Afua. *The Hanging of Angélique: The Untold Story of Canadian Slavery and the Burning of Old Montréal.* Toronto: HarperCollins Canada, 2006.

Dickey, Colin. *Ghostland: An American History in Haunted Places.* New York: Viking, 2016.

Henry, Natasha L. "Black Enslavement in Canada." *The Canadian Encyclopedia*. 16 June 2016. https://www.the canadianencyclopedia.ca/en/article/black-enslavement

Hutchins, Alex. "A glimpse of our haunted history." *The Concordian*. 30 October 2018. http://theconcordian. com/2018/10/a-glimpse-of-our-haunted-history/

Kilian, Crawford. *Go Do Some Great Thing: The Black Pioneers of British Columbia*. Vancouver: Commodore Books, 2008.

Machado, Carmen Maria. *Her Body and Other Parties*. London: Serpent's Tail, 2018.

Nelson, Charmaine A. "Black Cemeteries Force Us to Re-examine Our History with Slavery." *The Walrus*. June 2018.

Ostroff, Joshua. "Colonial Canada Had Slavery For More Than 200 Years. And Yes, It Still Matters Today." *Huffington Post*. 17 June 2017. https://www.huffingtonpost.ca/2017/06/17/ slavery-canada-history_n_16806804.html

Trudel, Marcel. *Canada's Forgotten Slaves: Two Hundred Years of Bondage*. Translated by George Tombs. Montreal: Véhicule Press, 2013.

Winks, Robin W. *The Blacks in Canada: A History*. Montreal: McGill-Queen's University Press, 1997.

Speakers for the Dead. Dir. David Sutherland & Jennifer Holness. National Film Board of Canada, 2000. Film.

"The Black Community." Salt Spring Island Archives. http:// saltspringarchives.com/multicultural/blacks/

"Torture and the Truth: Angélique and the Burning of Montreal." Great Unsolved Mysteries in Canadian History.

https://www.canadianmysteries.ca/sites/angelique/
accueil/indexen.html

Who Killed William Robinson? Race, Justice and Settling the
Land." Great Unsolved Mysteries in Canadian History.
https://www.canadianmysteries.ca/sites/robinson/
home/indexen.html

AMERICA AND THE ART OF EMPATHY

Asmelash, Leah. "A White professor says she has been
pretending to be Black for her entire professional
career." CNN. 4 September 2020. https://www.cnn.com/
2020/09/03/us/jessica-krug-gwu-black-trnd/index.html

Doležal, Rachel, & Reback, Storms. *In Full Color: Finding
My Place in a Black and White World*. Dallas: BenBella
Books, 2017.

Gaines, Alisha. *Black for a Day: White Fantasies of Race and
Empathy*. Chapel Hill: University of North Carolina
Press, 2017.

Griffin, John Howard. *Black Like Me*. New York: Signet, 1962.

Hobbs, Allyson. *A Chosen Exile: A History of Racial Passing in
American Life*. Cambridge: Harvard University Press, 2014.

Jackson, Lauren Michele. "The Layered Deceptions of Jessica
Krug, the Black-Studies Professor Who Hid That She Is
White." *New Yorker*. 12 September 2020.

Krug, Jessica A. "The Truth, and the Anti-Black Violence of My
Lies." *Medium*. 3 September 2020. https://medium.com/@
jessakrug/the-truth-and-the-anti-black-violence-of-my-
lies-9a9621401f85

Levenson, Michael, & Schuessler, Jennifer. "University Investigates Claim that White Professor Pretended to be Black." *New York Times.* 3 September 2020. https://www.nytimes.com/2020/09/03/us/jessica-krug-gwu-race.html

Patton, Stacey. "White people are speaking up at protests. How do we know they mean what they say?" *Washington Post.* 2 June 2020. https://www.washingtonpost.com/outlook/2020/06/02/white-people-black-protests/

Sandweiss, Martha A. *Passing Strange: A Gilded Age Tale of Love and Deception Across the Color Line.* New York: Penguin Books, 2009.

Singal, Jesse. "This Is What a Modern-Day Witch Hunt Looks Like." *New York Intelligencer.* 2 May 2017. https://nymag.com/intelligencer/2017/05/transracialism-article-controversy.html

Sparks, Hannah. "Grad student admits lying about being black, resigns teaching position." *New York Post.* 16 September 2020. https://nypost.com/2020/09/16/white-uw-madison-student-apologizes-for-lying-about-being-black/

Sprigle, Ray. "I was a Negro in the South for 30 Days." *Pittsburgh Post-Gazette.* 1948. http://old.post-gazette.com/sprigle/

Tuvel, Rebecca. "In Defense of Transracialism." *Hypatia.* Volume 32, Issue 2. Spring 2017.

Wald, Gayle. *Crossing the Line: Racial Passing in Twentieth-Century U.S. Literature and Culture.* Durham: Duke University Press, 2000.

Imitation of Life. Dir. John M. Stahl. Universal Pictures, 1934. Film.

Imitation of Life. Dir. Douglas Sirk. Universal Pictures, 1959. Film.

The Rachel Divide. Dir. Laura Brownson. Netflix, 2018. Film.

"American Lives: The 'Strange' Tale of Clarence King." NPR. 18 August 2010. https://www.npr.org/templates/story/story.php?storyId=129250977

"Are You Blacker Than A Rachel Dolezal? Quiz." Urban Daily. 12 June 2015. https://theurbandaily.com/3008512/askrachel-rachel-dolezal-quiz/

"Jess La Bombalera (Jessica Krug) — NYC City Council Testimony 6/9/20." YouTube. 4 September 2020. Video. https://www.youtube.com/watch?v=n4owEIFtImU

"Raw Interview with Rachel Dolezal." 4 News Now. YouTube. 11 June 2015. Video. https://www.youtube.com/watch?v=oKRj_h7vmMM

AFRICA AND THE ART OF THE FUTURE

Alpern, Stanley B. *Amazons of Black Sparta: The Women Warriors of Dahomey.* New York: New York University Press, 1998.

Bay, Edna G. *Wives of the Leopard: Gender, Politics, and Culture in the Kingdom of Dahomey.* Charlottesville: University of Virginia Press, 1998.

Dery, Mark, ed. "Black to the Future: Interviews with Samuel R. Delany, Greg Tate, and Tricia Rose." *Flame Wars: The*

Discourse of Cyberculture. Durham: Duke University Press, 1994.

Itzkoff, Dave. "A Young Director Brings a Spaceship and a Metaphor in for a Landing." *New York Times*. 5 August 2009. https://www.nytimes.com/2009/08/06/movies/06district.html

Khair, Zulkifli. "The University of Sankore, Timbuktu." Muslim Heritage. 7 June 2003. https://muslimheritage.com/the-university-of-sankore-timbuktu/

Lavender III, Isiah. *Afrofuturism Rising: The Literary Prehistory of a Movement*. Columbus: Ohio State University Press, 2019.

Manguel, Alberto. *The City of Words*. Toronto: House of Anansi Press, 2007.

Nkoloso, Edward Makuka. "We're Going to Mars! With a Spacegirl, Two Cats and a Missionary." 1964. http://tanguydlv.free.fr/en/Zambia-going-to-Mars.html

Okorafor, Nnedi. *Lagoon*. New York: Saga Press, 2014.

Scott, A. O. "District 9." *New York Times*. 13 August 2009.

Serpell, Namwali. "The Zambian 'Afronaut' Who Wanted to Join the Space Race." *New Yorker*. 11 March 2017.

Silverman, Steve. "The Zambian Space Program." *Useless Information* Number 137. 28 July 2020. Podcast. https://uselessinformation.org/podcast-137-the-zambian-space-program/

Watercutter, Angela. "Behind the Scenes of Black Panther's Afrofuturism." *Wired*. 12 February 2018. https://www.wired.com/story/black-panther-design/

Wheatcroft, Geoffrey. "Unscrambling Africa." *New York Times*. 17 May 1992. https://www.nytimes.com/1992/05/17/books/unscrambling-africa.html

Womack, Ytasha L. *Afrofuturism: The World of Black Sci-Fi and Fantasy Culture*. Chicago: Lawrence Hill Books, 2013.

Black Panther. Dir. Ryan Coogler. Marvel Studios, 2018. Film.

District 9. Dir. Neill Blomkamp. Sony Pictures, 2009. Film.

"Afronauts: Interview with Edward Nkoloso, Head of Zambia's Unofficial Space Program, Nov. 1964." YouTube. 20 July 2020. Video. https://www.youtube.com/watch?v=JZBY-Hb-TDw

"Zambia: Tomorrow the Moon." *Time*. 30 October 1964. http://content.time.com/time/subscriber/article/0,33009,876312-1,00.html

"The Zambian Space Programme." Royal Museums Greenwich. https://www.rmg.co.uk/stories/topics/zambian-space-programme

"Zambia's forgotten Space Program." Lusaka Times. 28 January 2011. https://www.lusakatimes.com/2011/01/28/space-program/

ASIA AND THE ART OF STORYTELLING

Anna, Cara. "African nations, US decry racism against blacks in China." *Washington Times*. 11 April 2020. https://www.washingtontimes.com/news/2020/apr/11/african-nations-us-say-blacks-mistreated-in-chines/

Cartwright, Mark. "The Seven Voyages of Zheng He."

World History Encyclopedia. 7 February 2019. https://www.worldhistory.org/article/1334/the-seven-voyages-of-zheng-he/

Davidson, Helen. "Chinese official: claims of racial targeting are 'reasonable concerns.'" *The Guardian.* 13 April 2020. https://www.theguardian.com/world/2020/apr/13/chinese-official-claims-racial-targeting-reasonable-concerns

Hernon, Matthew. "The African Samurai: The True Story of Yasuke, Japan's Legendary Black Warrior." *Tokyo Weekender.* 17 September 2020. https://www.tokyoweekender.com/2020/09/yasuke-african-samurai-japan/

Kapuściński, Ryszard. *The Other.* Translated by Antonia Lloyd-Jones. London: Verso, 2008.

Kristof, Nicholas D. "1492: The Prequel." *New York Times Magazine.* 6 June 1999. https://www.nytimes.com/1999/06/06/magazine/1492-the-prequel.html

Leupp, Gary. "Images of black people in late mediaeval and early modern Japan, 1543–1900." *Japan Forum.* April 1995.

Lockley, Thomas, & Girard, Geoffrey. *African Samurai: The Story of Yasuke, a Legendary Black Warrior in Feudal Japan.* New York: Hanover Square Press, 2019.

Lofton, Robin. "Africans and African Americans in China: A Long History, a Troubled Present, and a Promising Future?" Blackpast. 9 March 2015. https://www.blackpast.org/global-african-history/africans-and-african-americans-china-long-history-troubled-present-and-promising-future/

Marsh, Jenni. "The African Migrants Giving up on the Chinese Dream." CNN. 26 September 2016. https://www.cnn.com/2016/06/26/asia/africans-leaving-guangzhou-china/index.html

Marsh, Jenni. "Covid-19 drove hundreds of Africans out of Guangzhou. A generation of mixed-race children is their legacy." CNN. 18 March 2021. https://www.cnn.com/2021/03/17/china/africans-guangzhou-hnk-dst-intl/index.html

Marsh, Jenni, Deng, Shawn, & Gan, Nectar. "Africans in Guangzhou are on edge, after many are left homeless amid rising xenophobia as China fights a second wave of coronavirus." CNN. 12 April 2020.

Mohamud, Naima. "Yasuke: The mysterious African samurai." BBC News. 14 October 2019. https://www.bbc.com/news/world-africa-48542673

Russell, John G. "Excluded Presence: Shoguns, Minstrels, Bodyguards, and Japan's Encounters with the Black Other." Kyoto: Institute for Research in Humanities, Kyoto University. March 2008.

Schiller, Bill. "Big Trouble in China's Chocolate City." *Toronto Star*. 1 August 2009. https://www.thestar.com/news/insight/2009/08/01/big_trouble_in_chinas_chocolate_city.html

Viviano, Frank. "China's Great Armada." *National Geographic*. July 2005. Retrieved on Wordpress. https://nuhist234.files.wordpress.com/2018/09/chinas-great-armada-national-geographic.pdf

Wen Jiao. "Chinese sailors' legacy on Kenyan islands." *China Daily*. 5 July 2005. http://www.chinadaily.com. cn/english/doc/2005-07/05/content_457089.htm

Wilkerson, Isabel. *Caste: The Origins of Our Discontents*. New York: Random House, 2020.

Wong, Wilson. "McDonald's apologizes after restaurant in China bans black people." NBC News. 17 April 2020. https://www.nbcnews.com/news/nbcblk/mcdonald-s-apologizes-after-restaurant-china-bans-black-people-n1184616

Zajtman, Arnaud, & Rabaud, Marlène. "Les 'oubliés' du Katanga." France 24. YouTube. 18 March 2010. Video. https://www.youtube.com/watch?v=DqF32kl-JG8

"Protest in China over Guangzhou Death in Custody." BBC News. 20 June 2012. https://www.bbc.com/news/world-asia-china-18516876

ACKNOWLEDGEMENTS

I AM PROFOUNDLY GRATEFUL to the tireless and formidable Jane Warren, Ellen Levine, Martha Wydysh, Hannah Westland, Philip Coulter, Greg Kelly, Tom Howell, Peter Norman, Bruce Walsh, Michelle MacAleese, Maria Golikova, Gillian Watts, Debby de Groot, Jeff Mireau, the Eudgyans, the Prices, the lovely Cleo and Maddox, and, as ever, Steven, for his brilliance and support.

ACKNOWLEDGEMENTS

PHOTO CREDITS

EVERY EFFORT HAS BEEN made to contact copyright holders; in the event of an inadvertent omission or error, please notify the publisher. Grateful acknowledgement is expressed to the follow people and sources for permission to reprint these images.

Page i David Martin's *Portrait of Dido Elizabeth Belle Lindsay and Lady Elizabeth Murray* is in the public domain. Image courtesy of Wikimedia Commons.

Pages ii–iii Images courtesy of jackie sumell.

Page iv Johann Gottfried Haid's *Portrait of Angelo Soliman* courtesy of Österreichische Nationalbibliothek (PORT_00014769_01).

Page v (top) Kehinde Wiley (American, born 1977). *Napoleon Leading the Army Over the Alps*, 2005. Oil on canvas, 108 x 108 in. (274.3 x 274.3 cm).

Brooklyn Museum, Partial gift of Suzi and Andrew Booke Cohen in memory of Ilene R. Booke and in honor of Arnold L. Lehman, Mary Smith Dorward Fund, and William K. Jacobs, Jr. Fund , 2015.53. © Kehinde Wiley. Courtesy Sean Kelly Gallery, New York.

(bottom) Jacques-Louis David's *Bonaparte Crossing the Alps* is in the public domain. Image courtesy of Wikimedia Commons.

Page vi (top) Harmonia Rosales's *The Creation of God* courtesy of Harmonia Rosales.

(bottom) Piero di Cosimo's *Perseus Freeing Andromeda* courtesy of Gabinetto Fotografico delle Gallerie degli Uffizi.

Page vii Marie-Guillemine Benoist's *Portrait of Madeleine* is licensed under the Creative Commons Attribution 2.0 Generic license. Image courtesy of Wikimedia Commons.

Page viii (top) Still of Delilah (Louise Beavers) in her cook's cap with Peola (Dorothy Black) in her arms (*Imitation of Life*, 1934) courtesy of Universal Studios Licensing LLC.

(bottom) Still from *District 9* courtesy of Wingnut Films.

INDEX